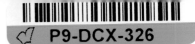

Photographs from the WILLIAM MERRITT CHASE ARCHIVES *at* THE PARRISH ART MUSEUM

Ronald G. Pisano

and

Alicia Grant Longwell

THE PARRISH ART MUSEUM
SOUTHAMPTON, NEW YORK

PHOTOGRAPHS
FROM THE
WILLIAM MERRITT CHASE
ARCHIVES AT
THE PARRISH ART MUSEUM
has been made possible through
the generous support of
Robert Baird/
 Polyesther Corporation
Robin S. Chase
Jerald Dillon Fessenden
Mrs. George Gould
Mr. and Mrs. Raymond Horowitz
Doris Merrill Magowan
The Henry Luce Foundation, Inc.
The Neil A. McConnell
 Foundation, Inc.
Newhouse Galleries, Inc.
Daniel and Joanna S. Rose
 Fund, Inc.
The Zilkha Foundation, Inc.
New York State Council
 on the Arts

front cover:
William Merritt Chase in costume,
c. 1880.

back cover:
William Merritt Chase, Florence,
c. 1911

*Photographs from the
William Merritt Chase Archives*
was exhibited at
The Parrish Art Museum
November 15, 1992
to January 3, 1993, organized by
Ronald G. Pisano and
Ellen Williams for
The Parrish Art Museum.

FOR EDYTHE CHASE, FOR HER
INVALUABLE ASSISTANCE
AND PERSONAL SUPPORT.

R G P

Foreword

The publication of *Photographs from the William Merritt Chase Archives* continues one of the most important and longstanding commitments of The Parrish Art Museum. In the course of publishing this volume, we have greatly advanced our knowledge of Chase's work and his artistic and everyday life. As Chase's life unfolds through this visual account, we also learn much about the setting of a critical period in American art. It is our hope that this publication will enable scholars, critics, and curators to deepen and revise the current understanding of Chase and his time.

For this effort the guiding force has been Ronald G. Pisano, the leading Chase scholar and former director and curator at The Parrish Art Museum. Over the years, his dedication to Chase and his ongoing association with the museum have brought wider recognition to the Parrish and greater understanding of Chase, and we are deeply grateful. This complex undertaking has drawn heavily on the expertise of our registrar, Alicia Longwell. We are especially indebted to her for her unusual insight and skill in coordinating this daunting number of photographs. Others who have been essential to this project are Noel Rowe in his skillful photographic work, Mindy Lang in her thoughtful design solutions, Marina Kucharczyk in her masterful typesetting, and Sara Blackburn in her generous editorial presence.

I must single out the contribution of Anke Jackson, the Parrish's Deputy Director, without whom this publication would not have been realized. She has assumed enormous administrative burdens throughout with patience and good will.

Without doubt, the Parrish's history is inextricably tied to the Chase family, and the Archives are a result of this unique relationship. We owe much to Jackson Chase Storm and Edythe Chase for sustaining this gratifying association and for helping us to know and understand Chase as they have.

A project of this magnitude requires substantial financial support, and we are very fortunate to have received generous sponsorship early on from the Henry Luce Foundation and the Neil McConnell Foundation. We owe special thanks to Bob Armstrong, former director of the Henry Luce Foundation, and Mary Jane Crook for acknowledging the importance of this endeavor; and to James G. Niven, former Parrish trustee, and Neil and Sandra McConnell, generous donors, we are most grateful. We are also indebted to the New York State Council on the Arts, the Daniel and Joanna S. Rose Fund, Inc., Robert B. Baird and Polyesther Corporation, Mr. and Mrs. Raymond Horowitz, The Zilkha Foundation, Inc., Newhouse Galleries, Inc., Doris Merrill Magowan, Jerald Fessenden, Mrs. George Gould, and Robin Chase for additional help, in supporting research and scholarship on Chase.

Our most important debt of gratitude is to the Parrish Board of Trustees, who have wholeheartedly endured our preoccupation with this project. The contribution it makes is, in large degree, theirs as well.

TRUDY C. KRAMER
Director

4

The William Merritt Chase Archives at The Parrish Art Museum document the life and art of one of America's most important artists and complement the museum's collection of Chase's art, the largest in the world. I first became aware of the documentary material housed at the Parrish in 1972 during the preparation of a two-part exhibition, "The Students of William Merritt Chase," sponsored jointly by the Parrish and The Heckscher Museum, Huntington, New York. At the time, the Parrish collection was a small, informal group of objects and emphemera related to the summer art school Chase had established at nearby Shinnecock Hills; it was gratifying to discover additional archival material owned by members of the Chase family, former Chase students, and their descendants. Subsequently, in 1976, as associate curator of the William Merritt Chase Collection and Archives, I was asked to research and catalogue all the works of art by Chase in the Parrish's collection. I realized the importance of identifying and formally listing what was in the archives, and began soliciting additional material. Letters of appeal were sent to potential donors, and an enthusiastic response followed. Boxes of letters, catalogues, memorabilia, and other ephemera came in—everything from Chase's original drawings to his inkwell and the curtains from his studio. Most relevant to our interests were the many photographs which entered the collection; several were isolated examples from remote sources, but most were in large lots, including entire photo albums. Some of the photographs were meticulously notated with dates and fully identified; others had to be researched and catalogued on the basis of this documentation and other resources.

When I became director of the museum in 1978, work on this project had to be curtailed, although material continued to be added to both the museum's collection of artwork by Chase and to the Chase archives. Much of the material in the archives was still uncatalogued when I left the museum in 1982, though all of it was continually available to scholars on an appointment basis. In fact, the growing interest in this material and the increasing number of requests for its use made it clear that the entire Chase holdings required cataloguing, and this undertaking began in 1989.

Because the core of the William Merritt Chase Archives and its most valuable asset in terms of scholarly interest are the documentary photographs, a serious effort has been made to identify them as fully as possible and, in turn, to publish the results of this research. Chase family members have been particularly helpful in this endeavor; several scholars have also offered valuable assistance. If these photographs had not been gathered together and catalogued, it is unlikely that they would be available for study today—indeed, some would most likely have been lost or discarded. For this reason, I am especially indebted to the donors of the photographs, as well as to those who contributed other documentary material to the William Merritt Chase Archives. In fact, I am grateful to everyone who recognized the importance of this project and supported my efforts to obtain, record, and preserve this valuable material. Undoubtedly there will be revisions to this catalogue as scholarship progresses and new material is discovered, but it is hoped that this work will serve as the basis for further research.

I would first like to thank Eva Gatling, formerly director of The Heckscher Museum, and Jean Weber, formerly director of The Parrish Art Museum, who supported my earliest research on William Merritt Chase in conjunction with the exhibition, "The Students of William Merritt Chase," funded in part by the Stebbins Family Foundation. I am also indebted to each of my first museum positions: consultant curator for The Heckscher Museum (1975–77) to catalogue the museum's American paintings and sculpture, and associate curator of the William Merritt Chase Collection and Archives at The Parrish Art Museum (1976–78). With Jean Weber's support, I began to establish the archives as an outgrowth of an extensive retrospective of Chase's work which I organized in 1976 at M. Knoedler & Company, New York, as a benefit for the museum.

I would also like to thank the major donors to the archives, without whom none of this enterprise would have been possible: Mrs. Lewis Balamuth; Mrs. Virginia Brumenschenkel; Chapellier Galleries; Mary M. Cross; John W. Ely; Mrs. Aileen Kaufmann; Mrs. A. Byrd McDowell; and Chase's grandson, Jackson Chase Storm, whose donations and loyal support were of great importance.

Over the past fifteen years many of The Parrish Art Museum's staff have contributed their time and efforts to the archives, and I would like to acknowledge their professional assistance as well: Karen Andrews; Madelyn Cohen; Chris Bergman; Helen Harrison; William Henry; Anke Jackson; Norma Loehner; Melinda Munford; Maureen O'Brien; Mary Dexter Stephenson; Margaret Tallet; and Penelope Wright. Of special assistance, both at the museum and afterwards, was Beverly Rood, who worked on the early stages of this project and continued to oversee details relating to it as my personal assistant in New York City; Betrina Darazsdi diligently assisted me in the final stages of cataloguing the material.

Technical advice with regard to conservation and storage of archival material was given by Konstanze Bachmann and Deborah Wythe, and was greatly appreciated. Copy prints of a number of the photographs were made by William H. Titus; all remaining copies were done by Noel Rowe. I also would like to thank Wendy Kail of The Phillips Collection, Washington, D.C., for her help in dating several of the photographs; and I would like to extend special thanks to Edythe (Mrs. Robert) Chase for her kind and most valuable assistance in identifying the people and places in many archival photographs and helping to establish their dates. I am also grateful to David Cassedy for his diligent editing of the introduction to this catalogue and his clarification with regard to terminology.

Finally, I would like to express my sincere gratitude to Trudy Kramer who, as director of The Parrish Art Museum since 1981, realized the importance of this project and committed herself to seeing it through to its completion; without her support, this publication never would have been possible. Alicia Longwell also deserves particular praise, not only for her patience, perseverance, and good humor, but for coordinating the final stages of this project and overseeing the daily operation of the William Merritt Chase Archives at The Parrish Art Museum.

RONALD G. PISANO

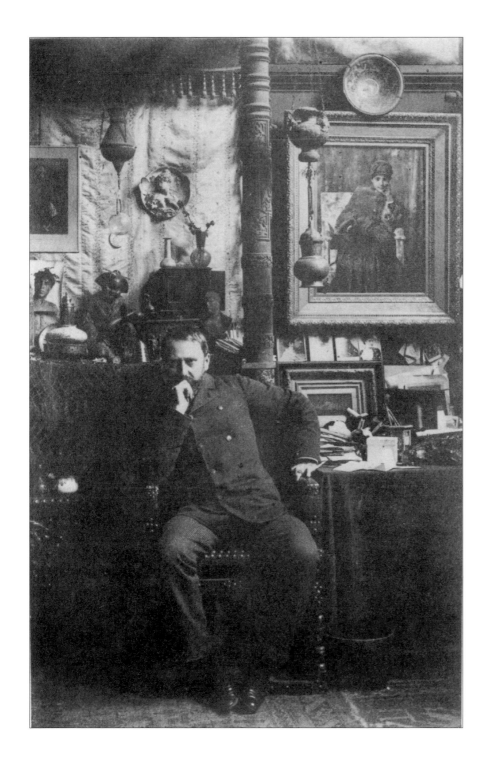

William Merritt Chase
in his Tenth Street studio, c. 1895

The epitome of success—a boy from a small town in Indiana who became an internationally celebrated artist—William Merritt Chase was the perfect painter to capture the confidence and enthusiasm of a prosperous America at the turn of the century. Scorning history painting and the literary and moralistic aspects of much Victorian art, he represented a more modern viewpoint in painting and chose to paint life as he saw it on a daily basis. Chase did not intend to produce a documentary art—his main concern was to create an aesthetic statement—but today his fresh, bright paintings remain as accomplished, candid images of upper-middle class America in a period referred to by some as the "picnic generation," alluding to the relatively carefree lives so many such Americans led at the time. His many portraits, figure studies, genre paintings, and landscapes form an absorbing chronicle of the lives of an American leisure class, documenting the clothes they wore, their customs and daily activities, the interiors of their homes, and the city parks and gardens they frequented. Some are more personal in nature, documenting his own cosmopolitan life, his home, family, and friends, as well as extensive travels abroad—with his wife, children, students, and associates as models. It is no surprise then that Chase's family photographs parallel and complement many of his paintings, even though he never used photographs to compose them.

The William Merritt Chase Archives include over 600 of these personal photographs, which capture the life of a personable artist at the same time that they provide a detailed picture of the lives of prosperous Americans at the turn of the century. The photographs also assist in dating Chase's paintings, identifying people who appear in them, and even authenticating his artwork. They span the period from Chase's early years in the midwest of the mid-1800s to his last summer art class conducted in California in 1914, two years before his death.

William Merritt Chase was born in Williamsburg (later renamed Ninevah), Indiana, November 1, 1849. He died sixty-seven years later in New York City on October 25, 1916. His rapid development from a clerk in his father's dry goods store to world-renowned artist is astounding, and his significance as an influential art teacher during this expansive period in American art is unsurpassed.

Chase's own art education began in 1867 with basic instruction from Barton S. Hays, an Indianapolis painter, followed by a brief period of study at the National Academy of Design in New York (1869–1871). His real training as an artist took place at the Royal Academy in Munich, where he devoted six years to the study of painting (1872–1878). Upon completing his studies in Munich, he was offered a teaching position at the prestigious Munich Academy, which he turned down to become an instructor at the newly founded Art Students League in New York City. There, in the fall of 1878, he began an impressive career as an art teacher. In later years he taught at the Pennsylvania Academy of the Fine Arts and the Art Institute of Chicago. He also founded two schools of his own: the Shinnecock Summer School of Art (Shinnecock Hills, Long Island)—the first important summer art school in America devoted to plein air painting—and the Chase School of Art, later renamed the New York School of Art (New York City, 1896–1907). From 1902 until 1914 Chase spent most of his summers abroad, where he taught classes in Lon-

don, Amsterdam, Bruges, Madrid, Venice, and Florence. His last summer classes were held in 1914 at Carmel-by-the-Sea, California.

Although he preferred to be classified as a "realist," who painted truthfully just what he saw before him, today Chase is heralded as one of the best "American Impressionist" painters. It is true that he adopted certain methods of the French Impressionists, such as a high-keyed palette and the use of cropped images to create a sense of immediacy, but he objected to their scientific concern with the effects of light. His own aesthetic sensibility was more closely aligned with James McNeill Whistler, who believed that a painter's primary concern should be the artistic nature of the composition.

The range of Chase's subject matter and the diversity of his materials are matched by few American artists of his day. His earliest success was in still life painting, the sales of which supported his study of art in the midwest and New York City. In Munich he specialized in figure painting and portraiture, winning awards in major international exhibitions and attracting important portrait commissions. Returning to America in 1878, he received even more acclaim for his portraits and figures, and soon turned to landscape painting, a practice he had learned from the Dutch plein air painters and perfected in Brooklyn and New York parks in the mid-to-late 1880s. These landscapes were followed by more impressionistic views of Shinnecock Hills, Long Island, where Chase spent his summer months, beginning in 1891. With the closing of his summer school of painting in 1902, Chase's landscapes begin to reflect his various trips abroad. Virtually all of his landscapes were painted between late spring and early fall; the rest of the year he spent teaching in major cities, mainly New York.

In the last decade of Chase's life, the still life became—once again—a major subject for his work. His bold, vigorous paintings of dead fish were acquired by America's most important art museums; so popular were they that Chase worried that ultimately he would be remembered only as a painter of dead fish. He need not have feared, for today he is best known for his fresh impressionistic landscapes, his charming genre paintings, and his dignified, arresting portraits of graceful women. As a master technician, he had few equals in oil painting in this country, and he was one of America's most accomplished pastelists (a founding member of the Society of Painters in Pastel in 1882); he also worked in watercolor, though rarely. In addition, Chase made etchings and monotypes; he was one of the earliest and most accomplished practitioners of the latter medium, in which paint or an oil-based ink is applied to a smooth plate and then the plate is pressed against paper to produce a single image.

Chase was a man of the world, but first and foremost he was an American artist, and proud of it. Unlike his contemporaries, the well-known expatriates James McNeill Whistler, John Singer Sargent, and Mary Cassatt, he chose to live in his native land and paint what he considered to be the predominant characteristics of the country and people he knew best. For this reason, his paintings have a distinctly American character to them. The paintings that are based on his frequent travel abroad reflect the cosmopolitan nature of his life. His work was widely exhibited in international exhibitions, throughout Europe and in

precincts as remote as Chile. His paintings were illustrated in art magazines around the world, including Russia, and he was one of the very few American artists to be commissioned by the Uffizi Gallery in Florence to paint a self-portrait for its collection. At a costume ball in Bruges in 1912, bedecked in many of the colorful foreign medals he had won, Chase was asked what character he portrayed. "William Merritt Chase, the Duke of Indiana!" was his witty reply.

When Chase died in 1916, his work was already being considered as old-fashioned by some of the younger artists and more progressive critics of the day. Although his work remained vital and displayed brilliant technical facility up to the last year of his life, modernist trends in art, which he vehemently opposed, were becoming a dominant form of artistic expression. Several of his own best students, including Georgia O'Keeffe, Charles Sheeler, and Joseph Stella, were among the earliest to adopt various modernist principles. It was emblematic of the period that in 1913, when many of his students were invited to show at the International Exhibition of Modern Art (better known today as the Armory Show), Chase was not—an intentional omission on the part of its organizers, though not a unanimous decision.

Just three months after Chase died, a memorial loan exhibition of his work was held at the Metropolitan Museum of Art in New York City (February 19–March 18, 1917). It consisted of 45 paintings and a number of pastels, drawings, monotypes, and etchings. Although the works exhibited spanned his career and included some of his best-known paintings, some critics considered it a hasty selection, made up of works most easily gathered in so short a period of time; it was pointed out that no loans had been secured from the many museums that owned his most prized works of art. Soon after the show closed, an auction was held (beginning May 14, 1917) in which Chase's private collection of paintings by his friends and colleagues were sold, along with much of his own work. Chase's own paintings sold for prices far below their market value, most falling into the $150 to $400 price range, and the sale was considered a disheartening failure by his close friends and by art critics. On a more positive note, an admiring monograph on Chase was published in 1917, written by a friend and former pupil, Katharine Metcalf Roof: *The Life and Art of William Merritt Chase*. This delightful biography was more of a personal appreciation than a serious assessment of Chase's importance as an artist, but it helped sustain Chase's reputation as a celebrated American artist and a beloved art teacher.

The first serious effort to revive interest in Chase's work and provide an accurate and scholarly account of his life took place in 1949, when Wilbur Peat organized the "Chase Centennial Exhibition" at the John Herron Art Museum in Indianapolis, Indiana (November 1–December 11) to commemorate the one hundredth anniversary of Chase's birth. A catalogue accompanied the show, including a checklist of all works of art that were attributed to Chase. The next retrospective exhibition of Chase paintings did not take place until nearly a decade later, when The Parrish Art Museum organized "William Merritt Chase/A Retrospective Exhibition" (June 30– July 27, 1957), which contained 124 paintings. The exhibition included many of the Chase paintings that had been donated to the Parrish by Rebecca Bolling Littlejohn Markoe, which now form the basis of the William Merritt Chase Collection.

Beginning in the 1960s and gaining strength in the 1970s, the interest in American art of the turn of the century, and particularly that of the American Impressionists, grew considerably, both in terms of museum exhibitions and collecting patterns. Among those at the forefront of this movement were the collectors Margaret and Raymond Horowitz, whose collection was exhibited at the Metropolitan Museum of Art in 1973 (April 19–June 3) under the title "American Impressionist and Realist Paintings and Drawings." Included in the exhibition were five superb works by Chase, showing him at his best in oil painting, pastel, and watercolor. The Horowitz's enthusiasm for Chase's work played a major role in generating further interest by other collectors, which paralleled The Parrish Art Museum's role in bringing the significance of Chase's work to the general public when in 1976 it supported my efforts to organize another major Chase retrospective exhibition. This show, "William Merritt Chase/A Benefit Exhibition for The Parrish Art Museum," included 108 works of art and was held at M. Knoedler & Company, New York City (May 7–June 5, 1976). The Parrish also generously cooperated with the next retrospective Chase show I organized for the Henry Art Gallery, University of Washington, Seattle, Washington in 1983, which later traveled to the Metropolitan Museum of Art and was accompanied by a monograph on Chase: *A Leading Spirit in American Art/William Merritt Chase, 1849–1916*. This was the second book I had written on Chase; the first, *William Merritt Chase*, published by Watson-Guptill in 1979, concentrated on a selection of individual paintings.

In recent years Chase's work has once again gained international recognition and apprecia-tion: two of his self-portraits have been on view in the Uffizi Gallery in Florence; his lovely painting of his daughter Alice Dieudonnée, *The Feather Fan*, is one of the few American paintings exhibited at the Musée d'Orsay in Paris, and another painting in which his daughter appears as his model, *The Japanese Print*, is on display at the Neue Pinakothek in Munich—all in the permanent collections of these museums. Additionally, requests for loans of Chase's paintings to European museums for special exhibitions increase on an annual basis.

Exhibitions devoted to specific aspects of Chase's career as an artist include "William Merritt Chase Portraits," organized by Carolyn Kinder Carr for the Akron Art Museum (June 5–August 29, 1982). The most recent exhibition of this sort was "William Merritt Chase/Summers at Shinnecock (1891–1902)," which focused on the paintings Chase did at Shinnecock Hills, Long Island. This show, organized by D. Scott Atkinson for the Terra Museum of American Art, Chicago (December 11, 1987–February 28, 1988) and Nicolai Cikovsky, Jr. for the National Gallery of Art, Washington, D.C. (September 6–November 29, 1987), displayed another aspect of Chase's immensely diverse career as an artist. It is inevitable that as Chase scholarship continues to develop with the support of museums, galleries, and private collectors, his work will be understood and appreciated even more, and that he will ultimately resume the stature he commanded at the turn of the century as one of America's most celebrated artists.

RONALD G. PISANO

Of the more than 600 photographs in the William Merritt Chase Archives at The Parrish Art Museum, almost all can be identified with respect to subject and approximate date; the source of the photographs, whether from Chase family or friends, can be traced; and the photographic processes themselves can be categorized. It is with considerably less certainty that we might speculate as to who actually made the majority of these pictures, specifically those photographs which chronicle the daily life of the very lively young family of William Merritt Chase. Nevertheless, evidence appears throughout the course of the photographs that leads us to conclude that it was Chase's wife, Alice, who recorded these moments and who, in the act of making these images, also found expression for her own artistic sensibilities.

Alice Gerson Chase grew up in New York City in a cultured and modestly well-to-do family where art was held in high regard and artists of the day were frequently guests. She writes that after viewing the 1878 Society of American Artists exhibition, she and her two older sisters, Minnie and Virginia, were very eager to meet the young artist whose vivid portrait of a beautiful young woman, *Ready for the Ride*, had caused such a sensation that season.[1] At their request, Frederick S. Church brought his friend and fellow artist William Merritt Chase to the Gerson home for the first of what were to be many evenings spent with the family. Alice Gerson was only fourteen, but during the next six years, as Chase's pursuit of the artistic life grew and his reputation expanded, his heart seems not to have ventured far from this youngest Gerson sister, whom everyone affectionately called "Toady." A contemporary of Chase's observed: "When she was a little girl she sat on a stool beside him and held his finger. When she was older she sat with her arm around his dog."[2] These tender images might almost be a description of the intimate scenes we later see in the touching photographs of Chase and his children.

The couple married in 1886, and with the subsequent birth of five daughters in seven years, William Merritt Chase often chose his family as the subject of his paintings, especially in the prolific decade of the nineties, when he founded the Shinnecock Summer School of Art and the family began to spend the summers together on Long Island's east end. As he posed his family in the studio, by the water, or in the Shinnecock Hills, here Alice Chase might have arranged to make her photographic portraits. Frequently in costume, often posed quickly amidst the clutter of a bedroom, Alice Dieudonnée, or Dorothy, or Helen were captured for a moment by the camera. She was not a skilled technician—often fingerprints are clearly visible on the prints—and photographic processes seem to have been something of a mystery to her: on a postcard to a family friend who shared her interest in photography she wrote, "...Will you order for me (to save time) one large size bottle of the brown liquid to photograph, or rather print with. I want it for a scheme I have."[3] But in what must have been a bustling household, Alice Chase was clearly highly motivated to take the time to create her own work. The cyanotype, a photographic print with an intense blue tonality, was popular with amateur photographers for its low cost and simple processing, and she often used it for photographs made of the family outdoors.

William Merritt Chase's last summer of teaching at Shinnecock was 1902, and in subsequent

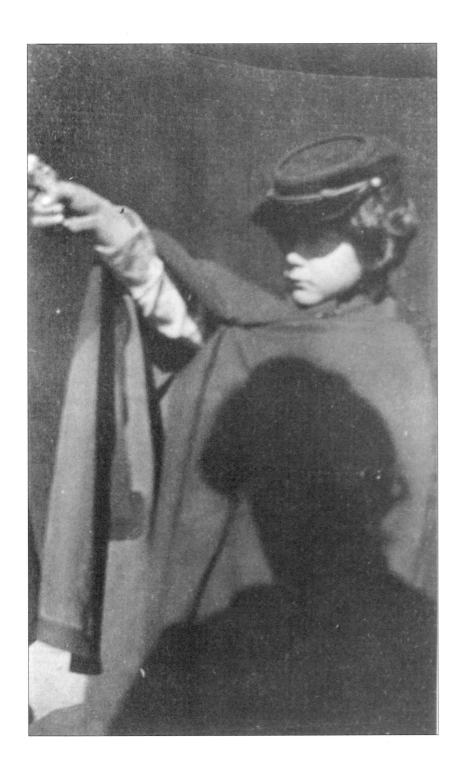

Roland Chase in uniform, c. 1910

summers he held classes in Europe and was far away from his family. His letters home to Alice frequently thank her for the photographs of the children and urge her to send more. His comments clearly acknowledge her artistic aspirations and her frequent successes: "I think those of Mary [Content] are quite the best you have ever made. They are *splendid*, composition and all. Hurrah for you!"[4]

As we look through the photographs in the William Merritt Chase Archives, we often catch a glimpse of Alice Gerson Chase herself, almost always wearing a beautiful large cross around her neck, one of many her husband is known to have brought back to her from his travels abroad.

In one photograph we see her putting up preserves, each jar marked with a large white heart—a symbol, perhaps, for "Lady Valentine," as one close friend dubbed her. Of particular interest is what accompanies one carefully mounted photograph of her daughter Dorothy, which bears a stamp in red ink on the lower right of the mount: the initials "A" inside "C," surrounded by a heart surmounted by a cross. Like many other artists of her day, Alice Gerson Chase created a cipher to sign her work—a symbol for the artistic spirit which animated her life and all she did.

ALICIA GRANT LONGWELL

[1] Katharine Metcalf Roof, *The Life and Art of William Merritt Chase* (New York, Charles Scribner's Sons, 1917), p. v.
[2] As quoted in Roof, p. 70.
[3] Postcard to Miss Bessie Fisher from Alice Gerson Chase, postmarked Shinnecock, N.Y., Sept. 10, 1909.
[4] As quoted in Roof, p. 244.

Chase's Parents
| David Hester Chase | unknown |
| Sarah Swaim Chase | 1825–c.1920 |

Chase and his Wife

| William Merritt Chase | November 1, 1849–October 25, 1916 |
| Alice Gerson Chase | May 29, 1866–March 31, 1927 |

Chase's Sisters-in-Law

| Minnie Gerson | 1853–March, 1927 |
| Virginia Gerson | 1864–Aug, 1951 |

Chase's Children

Alice Dieudonnée Chase	February 9, 1887–1971
Koto Robertine Chase	January 5, 1889–August, 1956
William Merritt Chase, Jr.	June 5, 1890–July 4, 1891
Dorothy Brémond Chase	August 24, 1891–1953
Hazel Neamaug Chase	August 2, 1893–February, 1949
Helen Velasquez Chase	1895–1965
Robert Stewart Chase	December 19, 1898–December 5, 1987
Roland Dana Chase	November 19, 1901–July 5, 1980
Mary Content Chase	February 2, 1904–1943

Chase's Sons-in-Law

| Arthur White Sullivan (Alice's husband) | born February 16, 1887 |
| Francis William Sullivan (Koto's husband) | February 16, 1887–March, 1963 |

On the following pages:
Dimensions are given in inches,
height precedes width.

THE EARLY YEARS: ARTISTIC AWAKENING

Munich · New York · London through 1890

[1] 89.Stm.18
Mrs. Chase's maternal
grandmother or great-grandmother
Brémond, c.1850s
albumen print
1³/₄ x 1¹/₄

[2] 85.Mcr.3
Emma Swaim Carpenter, possibly
one of Chase's mother's sisters
(inscribed with this name verso),
c. 1850s
albumen print
6¹/₂ x 4

[3] 89.Stm.50
Probably copy of portrait of
William Merritt Chase ancestor,
possibly his father, c.1840s;
photo enlargement by Jordan &
Co., 229 Greenwich St., NY,
no. 10113
gelatin silver print
10 x 8

[4] 89.Stm.13
Unidentified female child
(inscribed verso: "Charles D.
Fredericks & Co.,/'Specialite,'/
587 Broadway, New York"),
c.1850s
albumen print
3¹/₂ x 2, mounted on board
5¹/₄ x 3⁵/₈

[1]

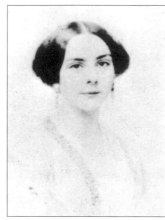

[2]

[3]

[4]

[5]

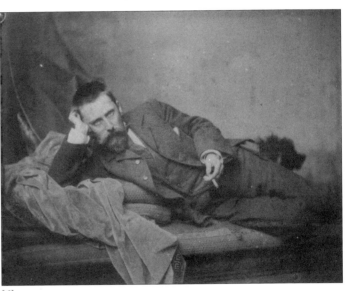

[6]

[5] 83.Stm.13
William Merritt Chase in peasant
costume for Munich ball, c.1875
albumen print
$4^{1}/_{4}$ x $2^{1}/_{2}$

[6] 78.Brl.8
William Merritt Chase, c.1878
albumen print
$2^{1}/_{2}$ x $3^{1}/_{2}$

[7] 89.Stm.91
William Merritt Chase's
Tenth Street studio, c.1879
gelatin printing-out paper
9¹/₄ x 7³/₄

[8] 83.Stm.10
Silhouette of William Merritt
Chase, 1880
gelatin silver print
4³/₄ x 4

[9] 83.Stm.8
Silhouette of Alice Gerson
(later Mrs. Chase), 1880
gelatin silver print
4³/₄ x 4

[10] 83.Stm.9
Silhouette of Walter Shirlaw, 1880
gelatin silver print
4³/₄ x 4

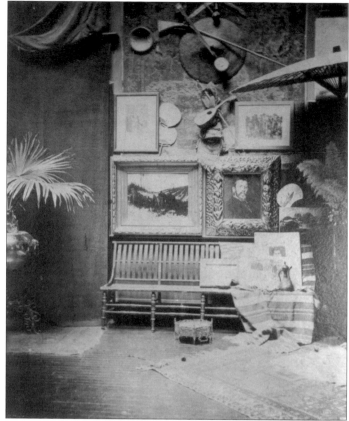

[7]

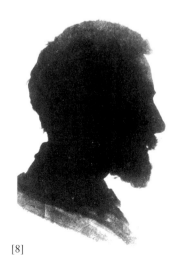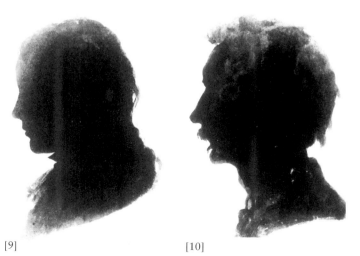

[8] [9] [10]

18

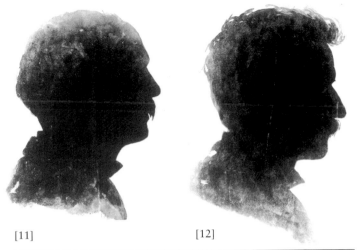

[11] [12]

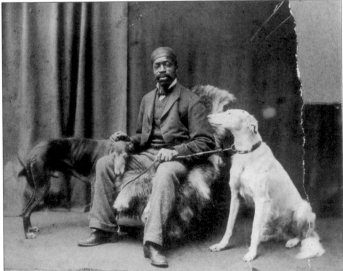

[13]

[14]

[15]

[11] 89.Stm.16
Silhouette of artist
Frederick Dielman, c.1880
gelatin silver print
$4^7/_8$ x 4

[12] 89.Stm.17
Silhouette of artist
Frederick S. Church, c.1880
gelatin silver print
$4^7/_8$ x 4

[13] 83.Stm.36
Chase's servant Daniel with
Chase's pet dogs, c.1880
gelatin silver print
$7^1/_2$ x $9^1/_2$

[14] 83.Stm.4
The Gerson sisters, Virginia, Alice,
and Minnie, with William Merritt
Chase, c.1880
tintype
5 x $6^3/_4$

[15] 83.Stm.34
William Merritt Chase in costume,
c.1880
albumen print
$5^3/_8$ x $3^3/_4$

[16] 89.Stm.4
Virginia Gerson, sister of
Mrs. William Merritt Chase,
with Chase's pet dog, c.1880
tintype
6¼ x 3½

[17] 83.Stm.49
The Jury (William Merritt Chase
seated at far right wearing top hat),
c.1882
albumen print
7⅝ x 9½

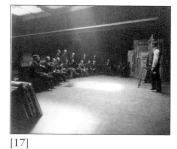

[17]

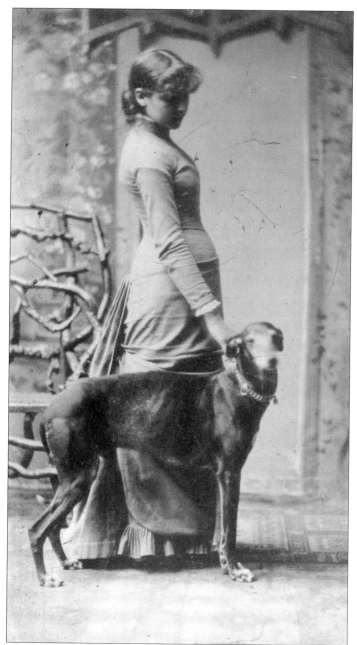

[16]

20

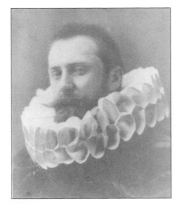

[18]

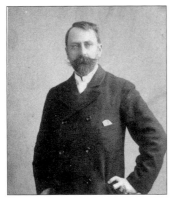

[19]

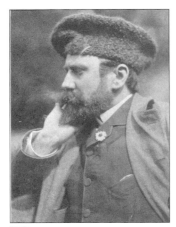

[20]

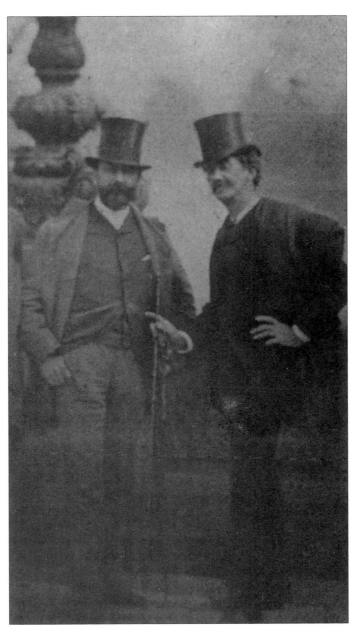

[21]

[18] 83.Stm.47
William Merritt Chase in
Van Dyck costume, c.1884
gelatin printing-out paper
9 x 7$\frac{1}{2}$

[19] 76.Mc.90
William Merritt Chase (inscribed
in ink on mount below image:
"To my friend Dr. Fisher/
Wm. M. Chase"), 1885
gelatin printing-out paper
4$\frac{7}{8}$ x 3$\frac{5}{8}$

[20] 77.G.1
William Merritt Chase [duplicate
83.Stm.39], (inscribed on mat
lower right by Chase: "To my
friend Mrs. Greer./ Wm. M. Chase/
New York Feb 25th 1888.")
c.1885
gelatin printing-out paper
7 x 4$\frac{3}{4}$, mounted on cardboard
10$\frac{1}{4}$ x 7$\frac{3}{8}$

[21] 89.Stm.2
William Merritt Chase and
James McNeill Whistler, London
(inscribed verso: "Delnaro/Italian
sculptor/with Johnson[?]"), 1885
gelatin silver print
3$\frac{1}{4}$ x 1$\frac{7}{8}$

[22] 89.Stm.69
l. to r.: unidentified man, James
McNeill Whistler, William Merritt
Chase, Mortimer Menpes, London,
1885
gelatin printing-out paper
$3^{1}/_{2}$ x $4^{1}/_{2}$

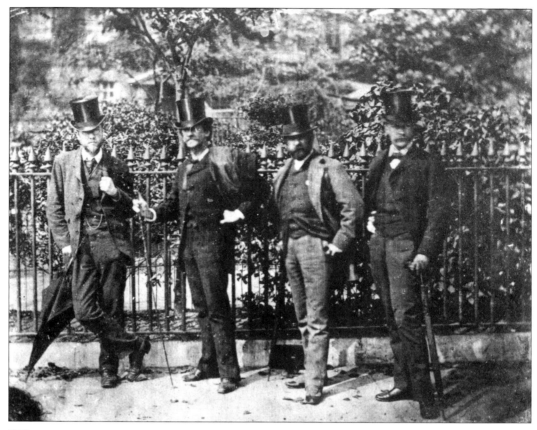

[22]

[23]

[23] 89.Stm.35
William Merritt Chase standing in
doorway, probably Tenth Street
studio [duplicate 89.Stm.80],
c.1885
gelatin silver print
6 x 4

[24] 83.Stm.53
William Merritt Chase dressed for
costume ball, [Chase in pose of
THE SMOKER, painting by Chase
of Frank Duveneck], c.1886
gelatin printing-out paper
7^1/$_2$ x 9^1/$_4$, mounted on cardboard
9 x 10^1/$_2$

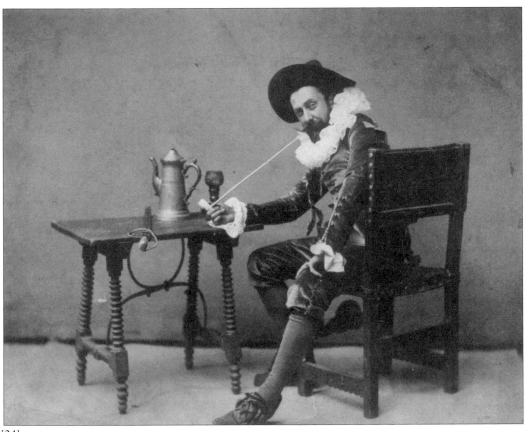

[24]

[25] 83.Stm.54
William Merritt Chase dressed for
a costume ball, c.1886
albumen print
9¹/₂ x 5¹/₄, mounted on board
12 x 8

[26] 83.Stm.51
Mr. and Mrs. William Merritt
Chase [duplicate 76.Mc.9], c.1886
gelatin silver print
7 x 8³/₄

[27] 83.Stm.14
Profiles of William Baer, Robert
Blum, William Merritt Chase,
c.1889
albumen print
3¹/₄ x 3⁵/₈

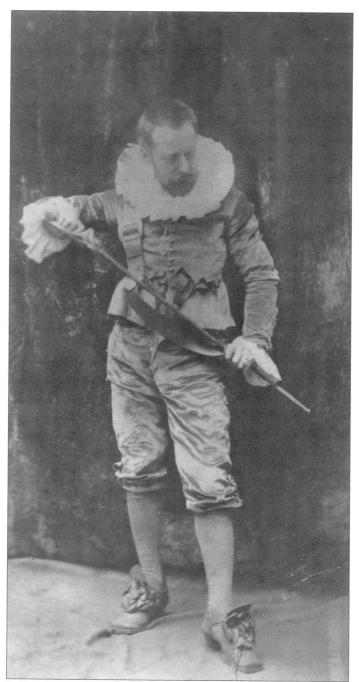

[25]

[26]

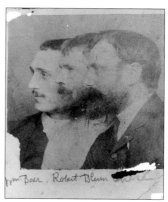

[27]

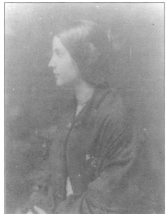

[28]

[29]

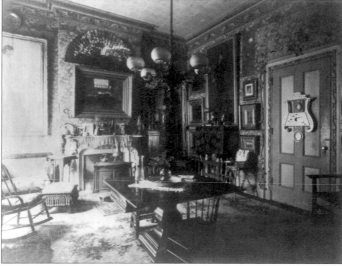

[30]

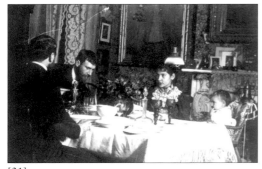

[31]

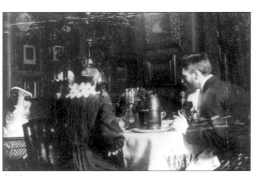

[32]

[28] 83.Stm.147
Mrs. Chase, c.1888
gelatin printing-out paper
3 x 2⅛, mounted on album page
13¾ x 15

[29] 91.RGP.3
William Merritt Chase, Alice
Dieudonnée, and Mrs. Chase,
at home, c.1888
gelatin printing-out paper
3¼ x 1¾, mounted on brown
paper 4½ x 3¼, irreg.

[30] 83.Stm.55
Chase home, after 1885
gelatin printing-out paper
9½ x 12¾, mounted on cardboard
14 x 16¾

[31] 89.Stm.74
Dining room of Chase home, seen
from left to right: William Merritt
Chase (with his back to the viewer),
Robert Blum, Mrs. Chase, and
Alice Dieudonnée, c.1888
gelatin printing-out paper
2¾ x 3¾

[32] 91.RGP.4
Mrs. Chase, Alice Dieudonnée,
Robert Blum, seated at table,
c.1888
gelatin printing-out paper
2⅞ x 4, mounted on brown paper
3¾ x 4⅝, irreg.

25

[33] 83.Stm.40
View of unidentified exhibition,
includes Chase's THE BLUE
KIMONO (The Parrish Art
Museum, Southampton, NY),
c.1890
gelatin printing-out paper
6¹/₂ x 9¹/₄

[34] 81.N.1
Robert Blum and William Merritt
Chase in Blum's New York studio,
taken shortly before Blum left for
Japan in 1890 (signed by both
artists verso)
gelatin printing-out paper
4³/₄ x 4

[35] 89.Stm.6
Minnie and Virginia Gerson,
sisters of Mrs. William Merritt
Chase (inscribed verso: "To Will/
from Minnie and Jennie."), c.1890
gelatin silver print
4³/₄ x 3⁵/₈, mounted on board
5³/₄ x 4³/₄

Unillustrated

[36] 78.Brl.3
Portrait of Emma Swaim
Carpenter as a child, n.d.
albumen print
3¹/₂ x 3¹/₂

[37] 78.Brl.2
Emma Swaim Carpenter,
photograph by A.G. Hicks,
Photographers, c.1865
albumen print
6¹/₂ x 1¹/₄

[38] 89.Stm.5
Unidentified woman (inscribed
verso: "Sarony/630 Broadway/
New York), c.1860s
albumen print
5³/₄ x 3⁷/₈, mounted on board
6 x 4¹/₄

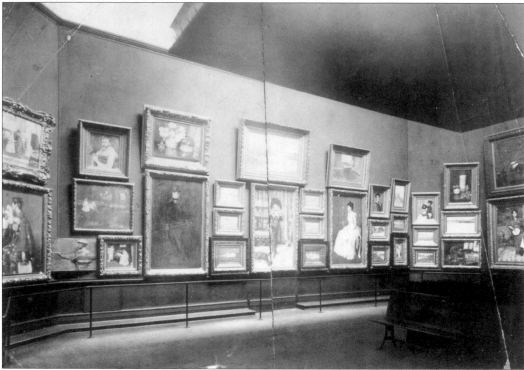

[33]

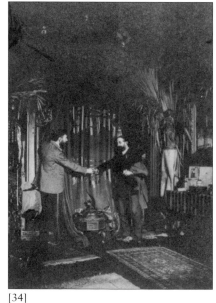

[34]

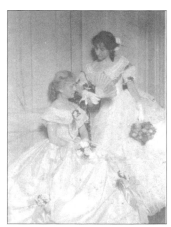

[35]

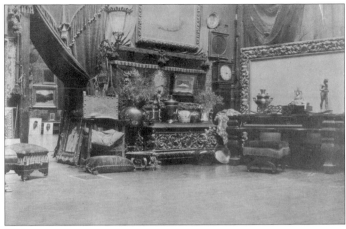

[39]

[40]

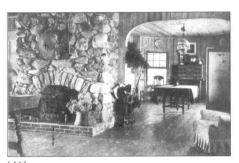

[41]

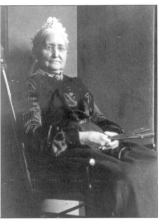

[42]

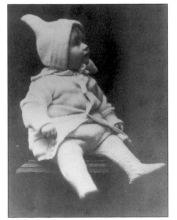

[43]

[39] 89.Stm.3
William Merritt Chase's
Tenth Street studio, NYC, c.1890s
gelatin silver print
4⅝ x 6¾

[40] 89.Stm.63
Seated infant, probably Koto,
c.1891
gelatin printing-out paper
2⅝ x 4¼

[41] 89.Stm.72
Hall and dining room of the Chase
summer homestead, Shinnecock
Hills, showing its stone fireplace
on which hangs Augustus Saint-
Gaudens's bas-relief PORTRAIT
OF WILLIAM MERRITT
CHASE, 1888. (The Metropolitan
Museum of Art, NY) (inscribed
verso: "Hall and dining room/
Shinnecock"), c.1892
gelatin printing-out paper
4½ x 6½, mounted on board
5⅜ x 7½

[42] 89.Stm.33
William Merritt Chase's mother,
Sarah Swaim Chase, c.1892
gelatin silver print
6¾ x 4⅝, mounted on cardboard
10 x 8

[43] 89.Stm.54
Dorothy (inscribed verso:
"Dorothy birthday/24 August"),
c.1892
gelatin silver print
5½ x 3½

[44] 83.Stm.35
William Merritt Chase outdoors
demonstrating before the
Shinnecock Summer School of Art
class, c.1892
albumen print
4³/₈ x 6³/₈

[45] 83.Stm.41
William Merritt Chase in his
Tenth Street studio, NYC, with
copies after Hals, Velázquez and
other Old Masters on the wall,
c.1895
albumen print
4¹/₂ x 7⁵/₈

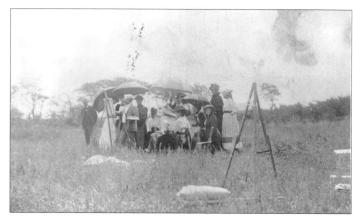

[44]

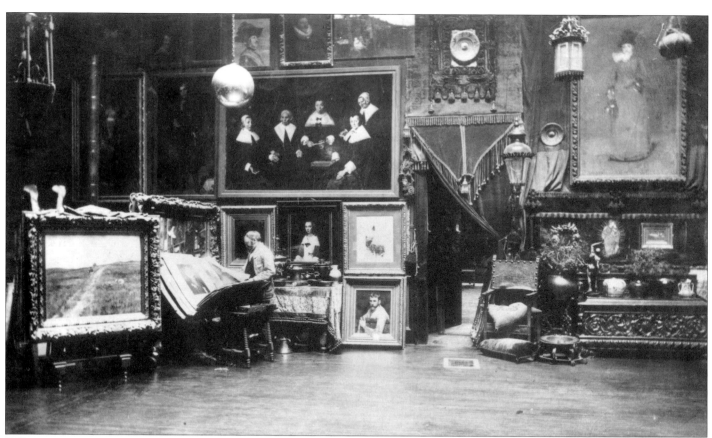

[45]

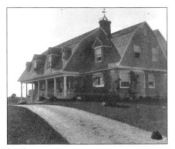

[46]

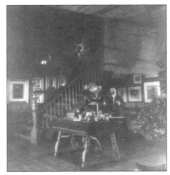

[47]

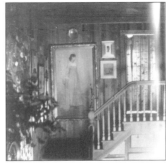

[48]

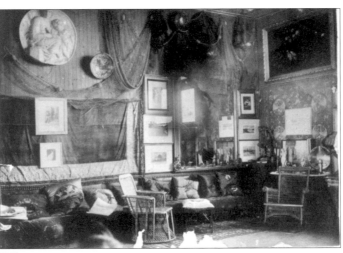

[49]

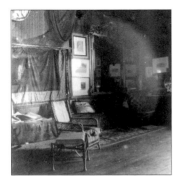

[50]

[46] 77.Mc.3
Chase house, Shinnecock Hills,
c.1895
gelatin printing-out paper
3³/₈ x 3⁵/₁₆

[47] 83.Stm.37
William Merritt Chase in the main
hall of his home, Shinnecock Hills,
c.1895
gelatin silver print
7¹/₂ x 7¹/₂

[48] 77.Mc.5
Chase home, Shinnecock Hills,
stairway leading to 2nd floor with
portrait of Virginia Gerson (now
called LADY IN PINK, Charles
and Emma Frye Museum, Seattle,
WA), c.1895
gelatin printing-out paper
3⁷/₁₆ x 3³/₈

[49] 89.Stm.73
William Merritt Chase's studio,
Shinnecock Hills (inscribed lower
right on front: "Shinnecock
Studio"), c.1895
gelatin printing-out paper
4⁵/₈ x 6¹/₂, mounted on cardboard
5⁵/₈ x 7³/₄

[50] 77.Mc.7
Chase's studio, Shinnecock Hills,
c.1895
gelatin printing-out paper
3⁷/₁₆ x 3³/₈

[51] 77.Mc.41
Mrs. Chase with Chase family
dog, Shinnecock Hills, c.1895
gelatin printing-out paper
3³/₁₆ x 3³/₁₆

[52] 77.Mc.31
Mrs. Chase seated in dunes,
Shinnecock Hills, c.1895
gelatin printing-out paper
1¹/₂ x 2

[53] 77.Mc.67
Mrs. Chase, c.1895
gelatin printing-out paper
4 x 3

[54] 76.Mc.58b
Dorothy and unidentified infant,
possibly Helen, c.1895
gelatin silver print
3¹/₄ x 3¹/₂, mounted on black board
10 x 8

[55] 76.Mc.63b
Dorothy [duplicate 85.Mcr.7],
c.1895
gelatin silver print
3¹/₈ x 3¹/₈, mounted on black board
10 x 8

[56] 76.Mc.73b
Dorothy, c.1895
gelatin printing-out paper
2³/₄ x 2¹/₂, mounted on black board
9 x 7

[57] 76.Mc.53
Dorothy, c.1895
gelatin silver print
4 x 2¹⁵/₁₆, mounted on black board
10 x 8

[58] 83.Stm.20
Canoe Place Inn, Shinnecock,
c.1895
gelatin silver print
4⁵/₈ x 6³/₈

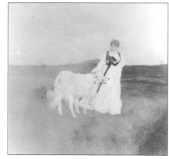

[51]

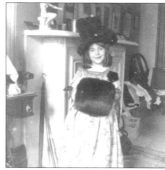

[52]

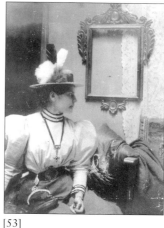

[53]

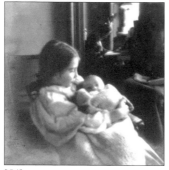

[54]

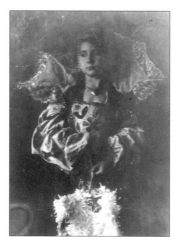

[55]

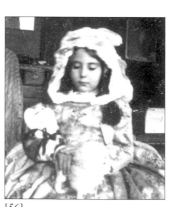

[56]

[57]

[58]

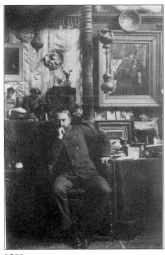

[59]

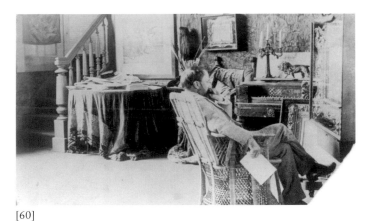

[60]

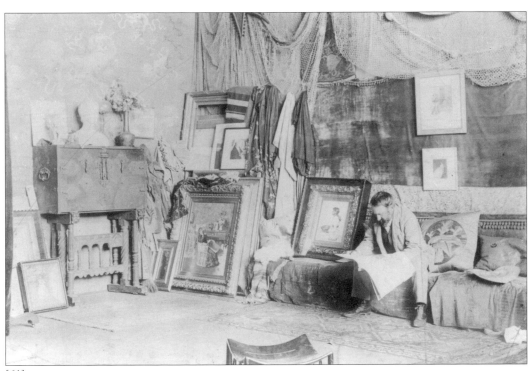

[61]

[59] 89.Stm.92
William Merritt Chase in his
Tenth Street studio, mimicking the
pose of his wife as seen in the
pastel MEDITATION (Private
Collection) hanging on wall
behind him [duplicate 75.C.4],
c.1895
gelatin silver print
10 x 8

[60] 83.Stm.16
William Merritt Chase in his
studio, Shinnecock Hills, c.1896
gelatin printing-out paper
3 x 5$^1/_8$

[61] 83.Stm.21
William Merritt Chase in his
studio, Shinnecock Hills, c.1896
albumen print
4$^5/_8$ x 6$^1/_8$

[62] 83.Stm.48
William Merritt Chase and
students, Madrid (stamped
"Carrera de Sn. Jeronimo/Madrid/
Conesco"), 1896
albumen print
6½ x 9

[63] 83.Stm.149
Cadwallader Washburn, Madrid,
1896
gelatin printing-out paper
4 x 3⅜, mounted on album page
13¾ x 15

[64] 76.Mc.50
Dorothy, c.1896
gelatin silver print
6 x 4, mounted on black board
10 x 8

[65] 77.Mc.15
Alice Dieudonnée and Chase
family dog, with painting in
background, THE FEATHER FAN
(Musée d'Orsay, Paris), c.1895
gelatin printing-out paper
1½ x 2

[66] 76.Mc.45
Dorothy, c.1896
gelatin silver print
6½ x 4½, mounted on black
cardboard 10 x 8

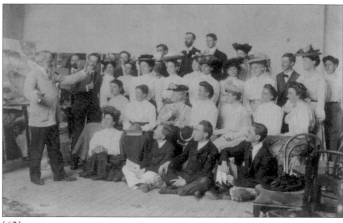

[62]

[63]

[64]

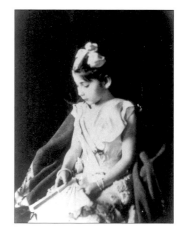

[65]

[66]

[67]

[68]

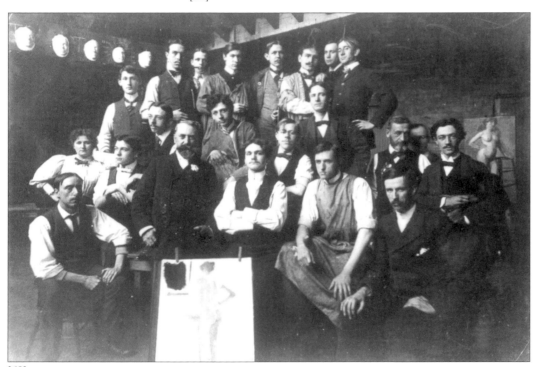

[69]

[67] 77.Mc.23
Alice Dieudonnée, unidentified
maid, and Dorothy, c.1897
gelatin printing-out paper
1⁵/₈ x 2

[68] 77.Mc.42
Alice Dieudonnée, c.1897
gelatin printing-out paper
2 x 1⁷/₁₆

[69] 89.Stm.51
William Merritt Chase class,
probably the Chase School of Art,
c.1897
gelatin silver print
5¹/₂ x 8, mounted on cardboard
7³/₄ x 10¹/₂ irreg.

[70] 76.Mc.70b
Dorothy, c.1897
gelatin printing-out paper
3$\frac{1}{4}$ x 3$\frac{1}{4}$, mounted on black board
9 x 7

[71] 77.Mc.33
Dorothy, c.1897
gelatin printing-out paper
3$\frac{1}{8}$ x 2$\frac{1}{4}$

[72] 77.Mc.16
Dorothy, c.1899
gelatin printing-out paper
1$\frac{7}{16}$ x 1$\frac{5}{8}$

[73] 77.Mc.19
Dorothy, c.1897
gelatin printing-out paper
1$\frac{1}{2}$ x 2

[74] 77.Mc.63
Dorothy, c.1897
gelatin printing-out paper
3$\frac{1}{8}$ x 2$\frac{3}{8}$

[70]

[71]

[72]

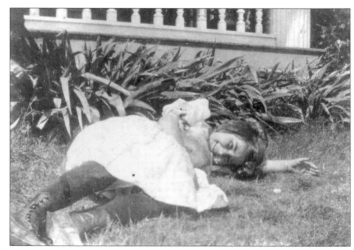

[73]

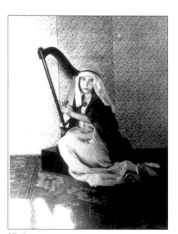

[74]

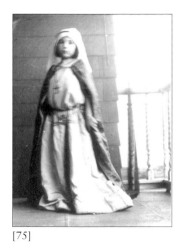

[75]

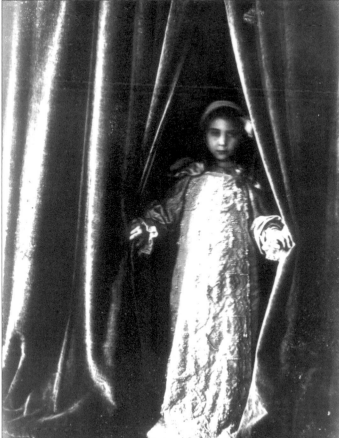

[76]

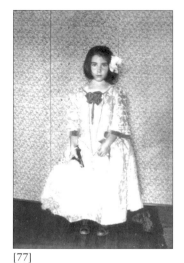

[77]

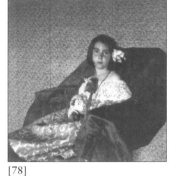

[78]

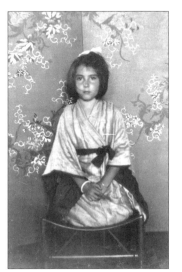

[79]

[75] 77.Mc.48
Dorothy, Shinnecock Hills, c.1897
gelatin printing-out paper
3¹/₄ x 2¹/₄

[76] 76.Mc.52
Dorothy, c.1897
gelatin silver print
6⁵/₈ x 4⁵/₈, mounted on black board
10 x 8

[77] 77.Mc.61
Dorothy dressed as Velázquez's
INFANTA [duplicate 76.Mc.71b],
c.1897
gelatin printing-out paper
3¹/₈ x 2¹/₈

[78] 77.Mc.58
Dorothy dressed as Velázquez's
INFANTA, c.1897
gelatin printing-out paper
3¹/₂ x 3³/₈

[79] 77.Mc.59
Dorothy [duplicate 76.Mc.72a],
c.1897
gelatin printing-out paper
3¹/₂ x 2¹/₄

[80] 76.S.1
Carolus-Duran giving a painting
demonstration to a Chase class,
New York City [duplicate
83.Stm.33], (inscribed on paper
backing verso: "Carolus-Duran of
Paris painting before art class of
William M. Chase in New York
[keep in House] K.S. Day"), c.1898
gelatin printing-out paper
(slightly out of focus)
5 x 4

[81] 77.Mc.68
Mrs. Chase in Spanish costume,
c.1898
gelatin printing-out paper
$3^{1}/_{2}$ x $3^{3}/_{8}$

[82] 77.Mc.43
Mrs. Chase in front of a large
Japanese umbrella, Shinnecock
Hills, c.1898
gelatin printing-out paper
$1^{13}/_{16}$ x $1^{1}/_{4}$

[83] 77.Mc.66
Mrs. Chase posed in fancy
costume, c.1898
gelatin printing-out paper
$3^{3}/_{8}$ x $3^{3}/_{8}$

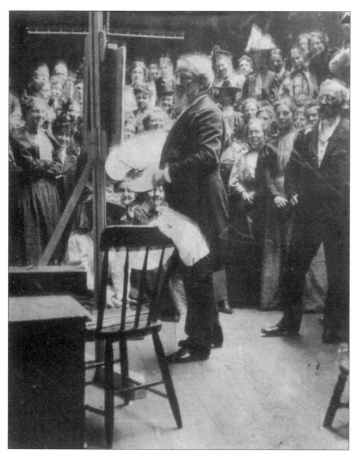

[80]

[81]

[82]

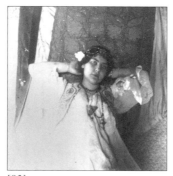

[83]

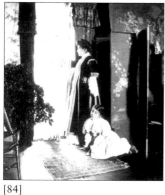

[84]

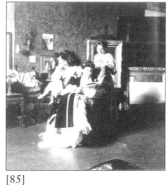

[85]

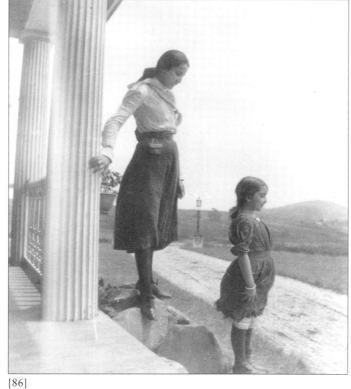

[86]

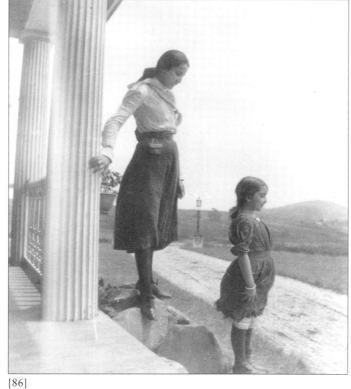

[87]

[84] 83.Stm.151
Mrs. Chase and Dorothy,
Shinnecock Hills, c.1898
gelatin printing-out paper
3½ x 3½, mounted on album page
14¼ x 15¼

[85] 83.Stm.152
Mrs. Chase (seated), Dorothy (left),
Alice Dieudonnée (behind),
Shinnecock Hills, c.1898
gelatin printing-out paper
3½ x 3½, mounted on album page
14¼ x 15¼

[86] 77.Mc.39
Alice Dieudonnée and Dorothy,
Shinnecock Hills, c.1898
gelatin printing-out paper
3⅜ x3⅛

[87] 76.Mc.38
Koto, c.1898
gelatin silver print
5 x 3½, mounted on black board
10 x 8

[88] 83.Stm.168
Hazel, Koto, Helen, Dorothy,
and Alice Dieudonnée (partially
hidden), Shinnecock Hills, c.1898
gelatin printing-out paper
3¼ x 3⅜, mounted on album page
14¼ x 15¼

[89] 76.Mc.81
Dorothy, c.1898
gelatin printing-out paper
4⅛ x 3, oval format printed on
penny postcard 5¼ x 3⅛

[90] 77.Mc.40
Helen (seated), Alice Dieudonnée
(standing), Dorothy (seated
foreground), Koto (standing), and
Hazel (seated) as seen from left to
right, Shinnecock Hills, c.1898
gelatin printing-out paper
3¼ x 3¼

[91] 76.Mc.8
Unidentified young woman dressed
for tableau vivant, probably
Shinnecock Hills, c.1898
gelatin silver print mounted on
board
8½ x 7¼

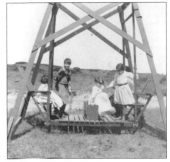

[88]

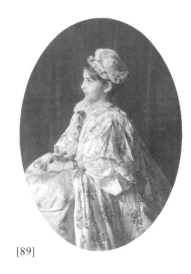

[89]

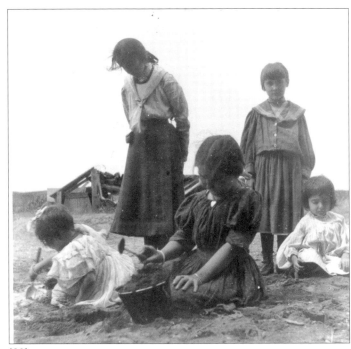

[90]

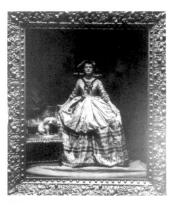

[91]

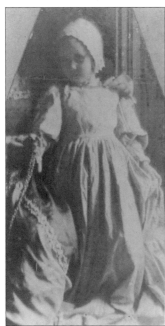

[92]

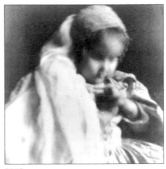

[94]

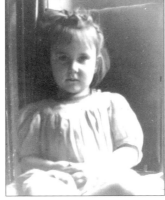

[93]

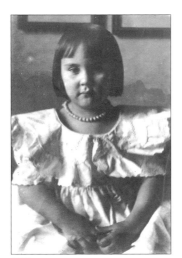

[95]

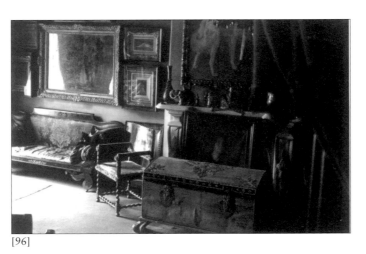

[96]

[92] 83.Stm.145
Helen, c.1898
gelatin printing-out paper
2⁵/₈ x 1¹/₄, mounted on album page
13³/₄ x 15

[93] 77.Mc.17
Helen, c.1898
gelatin printing-out paper
2 x 1⁵/₈

[94] 77.Mc.36
Helen, c.1898
gelatin printing-out paper
3³/₈ x 3¹/₄

[95] 76.Mc.62
Helen, c.1898
gelatin silver print
6 x 4, mounted on black board
10 x 8

[96] 76.Mc.5
Unidentified room with Chase
paintings on wall and floor,
including FRIENDS (The Parrish
Art Museum, Southampton, NY)
over fireplace, probably New York
City, after 1898
gelatin silver print
4³/₄ x 6¹/₂

[97] 85.Mcr.5
Mrs. Chase on stairway of Chase
house, Shinnecock Hills, c.1899
gelatin printing-out paper
6³/₈ x 4⁵/₈

[98] 83.Stm.155
Alice Dieudonnée in fancy costume,
c.1899
gelatin printing-out paper
2³/₄ x 1¹/₂, mounted on album page
14¹/₄ x 15¹/₄

[99] 83.Stm.146
Alice Dieudonnée in fancy costume,
c.1899
gelatin printing-out paper
3¹/₂ x 3¹/₄, mounted on album page
13³/₄ x 15

[100] 77.Mc.38
Dorothy and Alice Dieudonnée,
c.1899
gelatin printing-out paper
3³/₈ x 3¹/₄

[101] 77.Mc.37
Helen and Dorothy in fancy
costumes, c.1899
gelatin printing-out paper
3¹/₈ x 3¹/₄

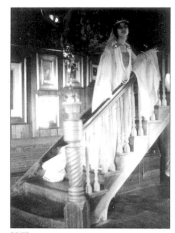

[97]

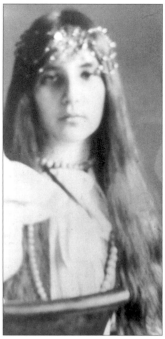

[98]

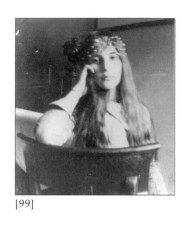

[99]

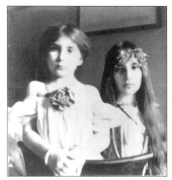

[100]

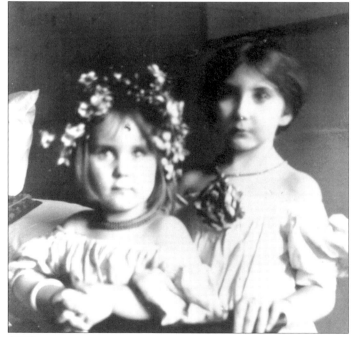

[101]

[102]

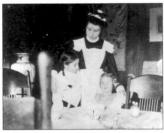

[104]

[105]

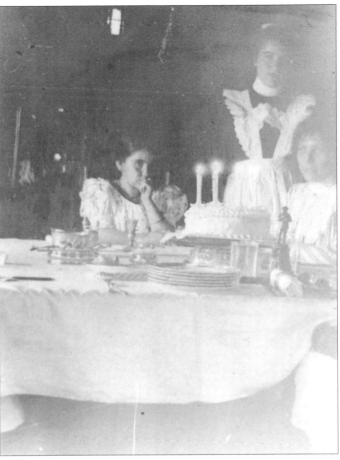

[103]

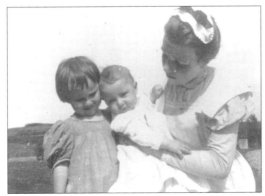

[106]

[102] 76.Mc.43
Alice Dieudonnée, c.1899
gelatin silver print
6 x 4, mounted on black board
10 x 8

[103] 83.Stm.167
Dorothy with unidentified maid
and unidentified woman at a
birthday party, c.1899
gelatin printing-out paper
1¼ x 1¾, mounted on album page
14¼ x 15¼

[104] 83.Stm.170
Dorothy, unidentified maid, and
Helen, Shinnecock Hills, c.1899
gelatin printing-out paper
2¾ x 5½, mounted on album page
14¼ x 15¼

[105] 83.Stm.160
Unidentified man, probably
Chase family gardener with Helen,
Shinnecock Hills, 1899
gelatin printing-out paper
1½ x 2, mounted on album page
14¼ x 15¼

[106] 77.Mc.24
Helen and Robert with unidentified
nursemaid, c.1899
gelatin printing-out paper
1½ x 2

[107] 76.Mc.85
Mrs. Chase holding infant son
Robert, 1899
gelatin silver print
5 x 4⅛

[108] 77.Mc.64
Mrs. Chase holding infant son
Robert [duplicate 76.Mc.72b],
c.1899
gelatin printing-out paper
3½ x 3¼

[109] 76.Mc.44
Mrs.Chase, c.1899
gelatin silver print
5 x 3⅜, mounted on black
cardboard 10 x 8

[110] 77.Mc.51
Alice Dieudonnée in kimono,
Shinnecock Hills, c.1899
gelatin printing-out paper
3½ x 3½

[111] 77.Mc.49
Helen in kimono, Shinnecock Hills,
c.1899
gelatin printing-out paper
3½ x 3¼

[112] 77.Mc.22
Helen, c.1899
gelatin printing-out paper
3¹/₁₆ x 1⅜

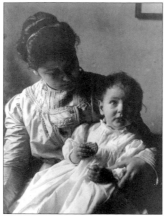
[107]

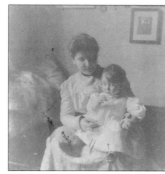
[108]

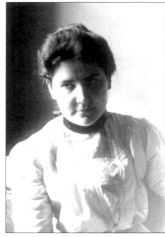
[109]

[110]

[111]

[112]

[113]

[114]

[115]

[116]

[117]

[118]

[113] 77.Mc.32
Helen, c.1899
gelatin printing-out paper
1¹³⁄₁₆ x 1¹⁄₄

[114] 76.Mc.82
Helen, c.1899
gelatin printing-out paper
4¹⁄₈ x 3, oval format printed on
penny postcard 5¹⁄₄ x 3¹⁄₈

[115] 76.Mc.39b
Helen, c.1899
gelatin silver print
3⁵⁄₁₆ x 3¹⁄₁₆, mounted on black
board 10 x 8

[116] 76.Mc.51
Helen, c.1899
gelatin silver print
4⁵⁄₈ x 3⁹⁄₁₆, mounted on black
board 10 x 8

[117] 76.Mc.42
Alice Dieudonneé dressed in fancy
costume for a tableau vivant,
c.1899
gelatin silver print
6 x 4, mounted on black board
10 x 8

[118] 76.Mc.64
Alice Dieudonnée dressed in fancy
costume for a tableau vivant,
c.1899
gelatin silver print
5³⁄₄ x 4, mounted on black board
10 x 8

[119] 76.Mc.59
Dorothy, c.1899
gelatin silver print
6 x 4, mounted on black board
10 x 8

[120] 77.Mc.34
Dorothy, c.1899
gelatin printing-out paper
3¹/₄ x 3¹/₄

[121] 76.Mc.67
Dorothy, c.1899
black and white photograph
6⁵/₁₆ x 4¹/₂, mounted on black
board 10 x 8

[122] 85.Mcr.12
Dorothy, Shinnecock Hills, c.1899
gelatin printing-out paper
6¹/₄ x 4⁵/₈

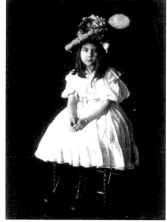

[119]

[120]

[121]

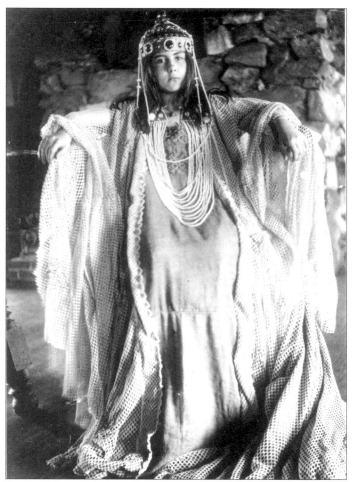

[122]

[123]

[124]

[125]

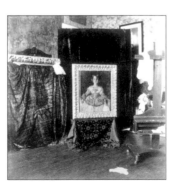

[126]

[123] 76.Mc.74b
Dorothy, c.1899
gelatin printing-out paper
3³/₁₆ x 3⁷/₈, mounted on black
board 9 x 7

[124] 77.Mc.56
Helen posed as Velázquez's
INFANTA, behind a frame for a
tableau vivant, with William
Merritt Chase adjusting the frame,
c.1899
gelatin printing-out paper
3¹/₂ x 3¹/₂

[125] 77.Mc.57
William Merritt Chase painting a
portrait of Helen as Velázquez's
INFANTA [duplicate 89.Stm.37],
c.1899
gelatin printing-out paper
3¹/₂ x 3³/₈

[126] 77.Mc.6
Chase house, probably his studio
with his portrait of his
daughter Helen, AN INFANTA,
A SOUVENIR OF VELASQUEZ
(Private Collection), Shinnecock
Hills, 1899
gelatin printing-out paper
3⁷/₁₆ x 3⁷/₁₆

[127] 89.Stm.79
Interior with Chase's painting
AN AFTERNOON STROLL
(San Diego Museum of Art),
c.1900
gelatin printing-out paper
8³/₄ x 9¹/₂

[128] 76.Mc.11
Dr. William R. Fisher (inscribed
verso: "November 1900/
Wm. R. Fisher."), 1900
gelatin silver print
5¹/₄ x 3³/₄, mounted on gray paper
8³/₄ x 7³/₄

[129] 89.Stm.24
William Merritt Chase and his
children: Dorothy, Robert, and
Helen, front porch of Chase
house, Shinnecock Hills, c.1904
gelatin silver print
4¹/₂ x 6¹/₂

[130] 83.Stm.150
Alice Dieudonnée, c.1900
gelatin printing-out paper
3³/₈ x 3, mounted on album page
13³/₄ x 15

[131] 76.Mc.69
Alice Dieudonnée, c.1900
gelatin printing-out paper
6¹/₄ x 4¹/₂, mounted on black board
9 x 7

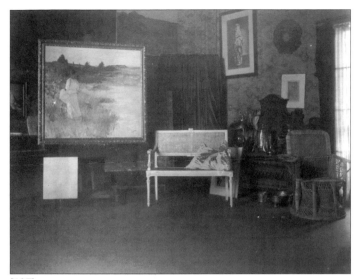
[127]

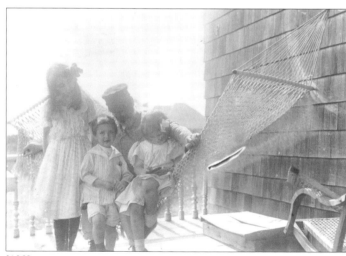
[129]

[128]

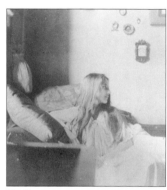
[130]

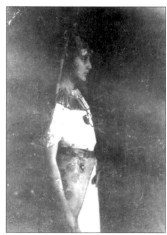
[131]

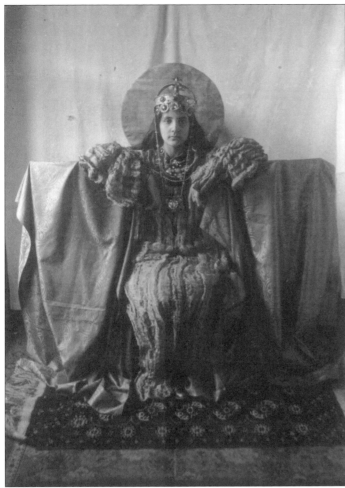

[132]

[133]

[134]

[132] 85.Mcr.9
Alice Dieudonnée, c.1900
gelatin printing-out paper
6¼ x 4½

[133] 76.Mc.63a
Alice Dieudonnée, c.1900
[duplicate 83.Stm.148]
gelatin silver print
3⁵⁄₁₆ x 2¾, mounted on black board
10 x 8

[134] 83.Stm.141
Alice Dieudonnée in fancy
costume, c.1900
gelatin printing-out paper
5½ x 3¾, mounted on album page
13¾ x 15

[135] 85.Mcr.17
Helen, c.1900
gelatin silver print
6¹/₂ x 4¹/₂

[136] 76.Mc.54
Robert, c.1900
gelatin silver print
5 x 3¹/₂, mounted on black board
10 x 8

[137] 77.Mc.54
Alice Dieudonnée posed in fancy
costume with tambourine,
behind a frame for a tableau vivant,
c.1900
gelatin printing-out paper
3¹/₂ x 3¹/₂

[138] 77.Mc.53
Alice Dieudonnée posed in fancy
costume behind a frame for a
tableau vivant, c.1900
gelatin printing-out paper
3¹/₂ x 3¹/₄

[139] 83.Stm.154
Mrs. Chase looking at paintings
by Chase, ALICE IN THE
SHINNECOCK STUDIO
(The Parrish Art Museum,
Southampton, NY) on floor, MRS.
FISHER (location unknown) on
easel, c.1900
gelatin printing-out paper
3¹/₂ x 3³/₈, mounted on album page
14¹/₄ x 15¹/₄

[135]

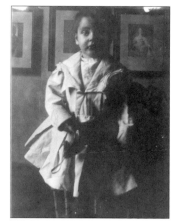

[136]

[137]

[138]

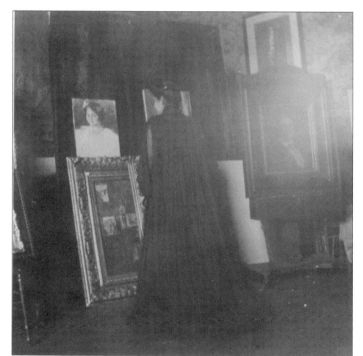

[139]

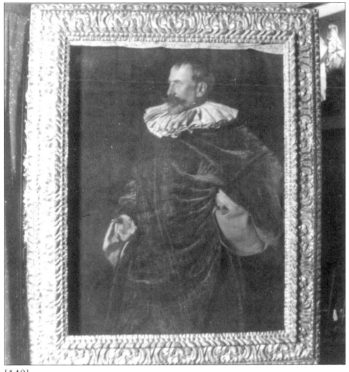

[140]

[142]

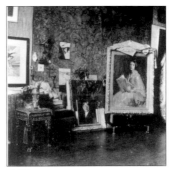

[141]

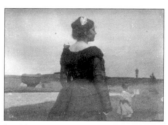

[143]

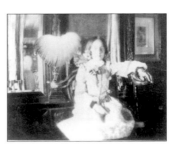

[144]

[140] 77.Mc.55
William Merritt Chase posed in fancy costume behind a frame for a tableau vivant, c.1900
gelatin printing-out paper
3^{1}/$_{2}$ x 3^{3}/$_{8}$

[141] 77.Mc.4
Chase house, probably his studio with Chase's painting of Frank Wadsworth on the floor, and portrait of one of his daughters on the easel, Shinnecock Hills, c.1902
gelatin printing-out paper
3^{3}/$_{8}$ x 3^{7}/$_{16}$

[142] 77.Mc.26
Mrs. Chase with Chase family dog, Chase house in the distance, Shinnecock Hills, c.1901
gelatin printing-out paper
1^{1}/$_{2}$ x 2

[143] 77.Mc.27
Mrs. Chase and possibly Robert, Shinnecock Hills, c.1901
gelatin printing-out paper
1^{1}/$_{2}$ x 2

[144] 77.Mc.30
Alice Dieudonnée, c.1901
gelatin printing-out paper
1^{7}/$_{16}$ x 1^{13}/$_{16}$

[145] 77.Mc.29
Alice Dieudonnée with Chase
family dog, Shinnecock Hills,
c.1901
gelatin printing-out paper
1½ x 2

[146] 77.Mc.28
Alice Dieudonnée, Shinnecock
Hills, c.1901
gelatin printing-out paper
1½ x 2

[147] 85.Mcr.10
Helen and Dorothy on the
front porch, Chase house,
Shinnecock Hills, c.1901
gelatin printing-out paper
6¼ x 4¾

[148] 85.Mcr.6
Dorothy, Helen, and Robert
outside Chase house,
Shinnecock Hills, c.1901
gelatin printing-out paper
6½ x 4¾

[145]

[146]

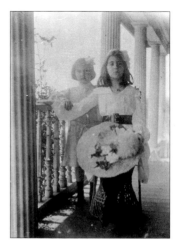
[147]

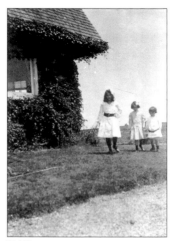
[148]

50

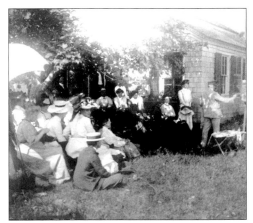

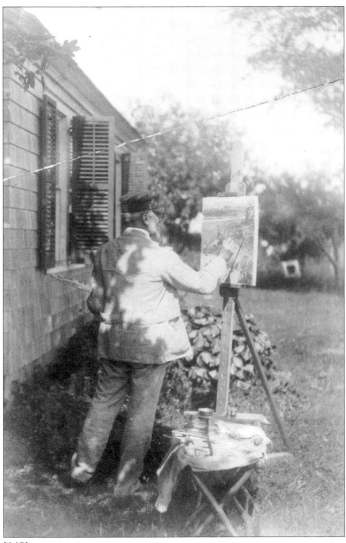

[149]

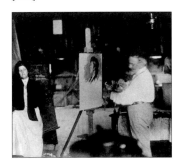

[151]

[152]

[149] 75.C.1
William Merritt Chase painting
a landscape, probably
Shinnecock Hills, c.1902
gelatin silver print
6¹/₂ x 4¹/₄

[150] 75.C.2
William Merritt Chase giving a
landscape demonstration before a
group of people, probably
Shinnecock Hills [expanded version
75.C.1], c.1902
gelatin silver print
6¹/₄ x 8¹/₈

[151] 75.C.3
William Merritt Chase painting a
portrait of his student Miss
Bellamy, probably a demonstration
piece for his class at the Shinnecock
Summer School of Art, c.1902
gelatin silver print
4¹/₄ x 6¹/₂

[152] 91.RGP/PS.29
MISS BELLAMY demonstration
piece (inscribed verso: "Painted
before class this summer—
Miss Bellamy—student"), 1902
gelatin printing-out paper
1¹/₂ x 2

[153] 89.Stm.42
William Merritt Chase standing in
front of his portrait MRS. CHASE
IN PINK (Davenport Municipal
Art Gallery, Davenport, IA)
on easel, c.1902
gelatin silver print
7³/₄ x 4³/₄

[154] 83.Stm.31
William Merritt Chase, c.1902
gelatin silver print
6³/₄ x 4³/₄

[155] 83.Stm.25
William Merritt Chase
[duplicate 89.Stm.36], c.1902
gelatin silver print
6³/₄ x 4⁵/₈

[156] 89.Stm.21
William Merritt Chase and family
dog on front porch of Chase
house, Shinnecock Hills, c.1902
gelatin silver print
3¹/₄ x 3

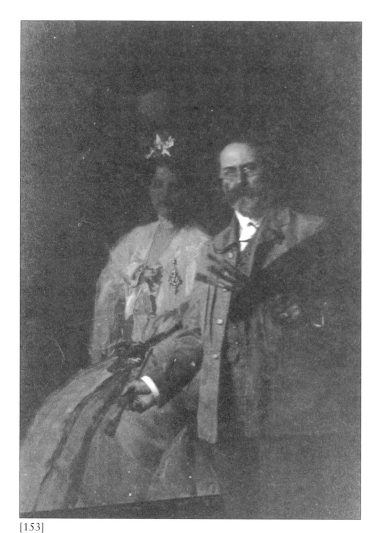

[153]

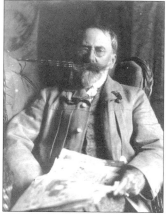

[154]

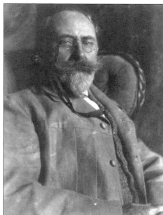

[155]

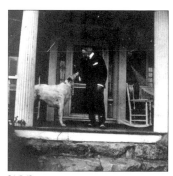

[156]

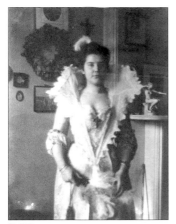

[157]

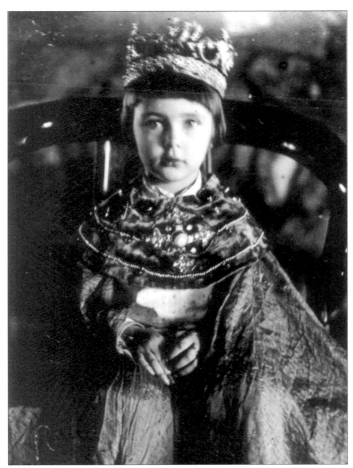

[158]

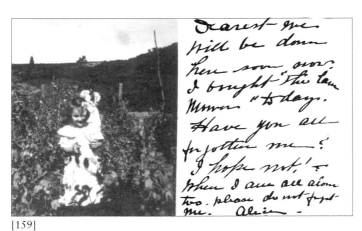

[159]

[157] 76.Mc.47
Mrs. Chase, c.1902
gelatin silver print
5⁵/₁₆ x 4, mounted on black board
10 x 8

[158] 85.Mcr.11
Robert, c.1902
gelatin printing-out paper
4⁷/₈ x 4¹/₈

[159] 76.Mc.84
Helen (foreground), possibly
Dorothy behind her
gelatin printing-out paper
3¹/₄ x 2³/₄, printed on penny
postcard, postmarked June [?],
1902, Newark, with note to
Mrs. Wm. M.R. Fisher,
Halcyon, PA

[160] 85.Mcr.2
Unidentified house, probably in
the "Art Village," Southampton,
NY, c.1890s
gelatin silver print
$3^5/8$ x $4^5/8$

[161] 89.Stm.58
Unidentified woman in the
Shinnecock dunes (possibly
Mrs. Chase), c.1892
gelatin silver print
$4^3/8$ x $6^1/4$

[162] 77.Mc.2
Chase house, Shinnecock Hills,
c.1895
gelatin printing-out paper
$3^7/16$ x $3^7/16$

[163] 77.Mc.1
Chase house, probably hallway on
second floor, Shinnecock Hills,
c.1895
gelatin printing-out paper
3 x $1^5/8$

[164] 89.Stm.20
Unidentified young woman,
possibly Alice Dieudonnée,
in fancy costume, Shinnecock Hills,
c.1899
gelatin silver print
$3^1/4$ x $2^1/4$

[165] 76.Mc.58a
Dorothy and unidentified infant,
possibly Helen, c.1895
gelatin silver print
$3^1/4$ x $3^1/2$, mounted on black board
10 x 8

[166] 76.Mc.73a
Dorothy, c.1895
gelatin printing-out paper
3 x $2^5/8$, mounted on black board 9
x 7

[167] 75.C.4
William Merritt Chase in the
Tenth Street studio, mimicking the
pose of his wife, as seen in the
pastel MEDITATION (Private
Collection) hanging on the wall
behind him [duplicate 89.Stm.92],
c.1895
gelatin silver print
6 x $3^3/4$

[168] 85.Mcr.7
Dorothy [duplicate 76.Mc.63b],
c.1895
gelatin printing-out paper
$6^1/4$ x $4^1/4$

[169] 76.Mc.70a
Dorothy, c.1897
gelatin printing-out paper
$3^1/8$ x $3^1/8$, mounted on black board
9 x 7

[170] 77.Mc.46
Unidentified child posed in fancy
costume, c.1900
gelatin printing-out paper
$3^1/2$ x $3^5/8$

[171] 76.Mc.72a
Dorothy [duplicate 77.Mc.59],
c.1899
gelatin printing-out paper
3 x $2^7/16$, mounted on black board
9 x 7

[172] 77.Mc.62
Dorothy, c.1897
gelatin printing-out paper
3 x 2

[173] 77.Mc.60
Dorothy in fancy costume
[duplicate 76.Mc.71a], c.1897
gelatin printing-out paper
$3^1/4$ x $2^1/8$

[174] 76.Mc.71a
Dorothy [duplicate 77.Mc.60],
c.1897
gelatin printing-out paper
$2^7/8$ x $2^3/8$, mounted on black board
9 x 7

[175] 77.Mc.65
Mrs. Chase in Spanish costume,
c.1898
gelatin printing-out paper
$3^1/2$ x $3^3/8$

[176] 85.Mcr.15
Dorothy, c.1896
gelatin printing-out paper
$5^5/8$ x $4^1/2$

[177] 76.Mc.86
Mrs. Chase, c.1898
gelatin silver print
$4^{15}/16$ x $3^5/8$

[178] 83.Stm.142
Helen, Shinnecock Hills, c.1898
gelatin printing-out paper
$1^3/8$ x $1^1/16$, mounted on album page
$13^3/4$ x 15

[179] 83.Stm.33
Carolus-Duran demonstration
[duplicate 76.S.1], c.1898
gelatin silver print
5 x 4, mounted on cardboard
$5^1/2$ x $4^1/2$

[180] 83.Stm.163
Dorothy, Shinnecock Hills, c.1898
gelatin printing-out paper
$1^1/4$ x $1^1/2$, mounted on album page
$14^1/4$ x $15^1/4$

[181] 83.Stm.164
Dorothy and Alice Dieudonnée,
porch of home, Shinnecock Hills,
c.1898
gelatin printing-out paper
$1^3/8$ x $1^3/8$, mounted on album page
$14^1/4$ x $15^1/4$

[182] 76.Mc.72b
Mrs. Chase and infant son Robert,
[duplicate 77.Mc.64], c.1899
gelatin printing-out paper
$3^5/16$ x $1^3/16$, mounted on black
board 9 x 7

[183] 89.Stm.37
William Merritt Chase painting
a portrait of Helen dressed as
Velàzquez's INFANTA
[duplicate 77.Mc.57], c.1899
gelatin silver print
5 x 4

[184] 83.Stm.159
Dorothy and Helen with
unidentified young woman,
Shinnecock Hills, 1899
gelatin printing-out paper
$1^1/2$ x $1^5/8$, mounted on album page
$14^1/4$ x $15^1/4$

[185] 77.Mc.50
Alice Dieudonnée, Shinnecock
Hills, c.1899
gelatin printing-out paper
$2^5/8$ x $3^3/8$

[186] 76.Mc.48
Alice Dieudonnée, c.1899
$6^3/16$ x $4^5/16$, mounted on black
board 10 x 8

[187] 76.Mc.61
Alice Dieudonnée, c.1899
gelatin silver print
6 x 4, mounted on black board
10 x 8

[188] 76.Mc.68
Dorothy, c.1899
gelatin silver print
$6^5/8$ x $4^1/2$, mounted on black board
10 x 8

[189] 76.Mc.66
Dorothy, c.1899
gelatin silver print
$6^3/4$ x $4^5/8$, mounted on black board
10 x 8

[190] 76.Mc.46
Dorothy, c.1899
gelatin silver print
6½ x 4½, mounted on black board
10 x 8

[191] 76.Mc.55
Dorothy, c.1899
gelatin silver print
6⅝ x 4⅝, mounted on black board
10 x 8

[192] 76.Mc.49
Alice Dieudonnée, c.1899
6⅜ x 4, mounted on black board
10 x 8

[193] 83.Stm.148
Alice Dieudonnée in fancy
costume [duplicate 76.Mc.63a],
c.1900
gelatin printing-out paper
3¼ x 3, mounted on cardboard
13¾ x 15

[194] 77.Mc.47
Unidentified child, c.1900
gelatin printing-out paper
3⅝ x 3½

[195] 83.Stm.144
Alice Dieudonnée, c.1900
gelatin printing-out paper
3¼ x 2¼, mounted on album page
13¾ x 15

[196] 77.Mc.25
Possibly Roland being held by
Mrs. Chase, c.1902
gelatin printing-out paper
1½ x 2³/₁₆

[197] 89.Stm.36
William Merritt Chase seated
[duplicate 83.Stm.25], c.1902
gelatin silver print
6¾ x 5

[198] 85.Mcr.19
Robert (seated), Dorothy
(kneeling), and Helen (seated),
c.1902
gelatin printing-out paper
6½ x 4¾

[199] 91.RGP/PS.4
Lincoln Park (identified verso),
c.1902
gelatin printing-out paper
1½ x 2

[200] 91.RGP/PS.6
Lincoln Park, Winter (identified
verso), c.1902
gelatin printing-out paper
1½ x 2

[201] 91.RGP/PS.7
Lincoln Park (identified verso),
c.1902
gelatin printing-out paper
1½ x 2

[202] 91.RGP/PS.9
Lincoln Park (identified verso),
c.1902
gelatin printing-out paper
1½ x 2

[203] 91.RGP/PS.10
"S.F.W." in Lincoln Park
(identified verso), c.1902
gelatin printing-out paper
1½ x 2

[204] 91.RGP/PS.14
Young man painting (probably an
art student at Shinnecock Hills,
L.I.), c.1902
gelatin printing-out paper
1½ x 2, mounted on cardboard mat
2⅞ x 3⅝, (stamped bottom center:
"POCKET KODAK")

[205]

EVENTFUL YEARS
IN ART AND LIFE
New York · Shinnecock Hills ·
Philadelphia
1891 *through* 1902

[205] 89.Stm.70
Display of works by William
Merritt Chase students, probably
set up for a critique, and judging
by subjects portrayed, probably
Chase's summer class in Holland,
1903, or in Bruges, 1912
gelatin silver print
7 x 9½

[206] 85.Mcr.1
Helen and Robert, c.1903
gelatin printing-out paper
4¼ x 3⅛

[207] 83.Stm.166
Alice Dieudonnée and Roland in
front of home, Shinnecock Hills,
c.1903
gelatin printing-out paper
3½ x 3½, mounted on album page
14¼ x 15¼

[206]

[207]

[208] 76.Mc.88
Helen, Robert, Dorothy, and
Roland (l. to r.), Shinnecock Hills,
c.1903
cyanotype
2¼ x 3¼

[209] 76.Mc.87
Robert, Roland, and Helen,
Shinnecock Hills, c.1903
cyanotype
2¼ x 3¼

[210] 83.Stm.162
Roland, c.1903
gelatin printing-out paper
1¼ x 1⅛, mounted on album page
14¼ x 15¼

[211] 77.Mc.21
Roland playing croquet,
Shinnecock Hills, c.1903
gelatin printing-out paper
1⁷⁄₁₆ x 2

[212] 77.Mc.35
Roland and unidentified maid,
1903
gelatin printing-out paper
3¼ x 3

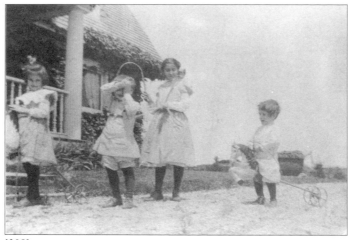

[208]

[210]

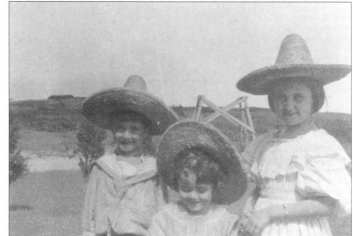

[209]

[211]

[212]

[213]

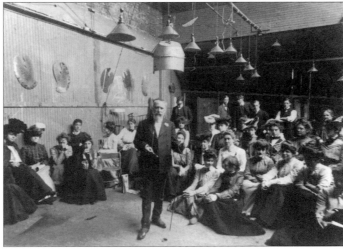

[214]

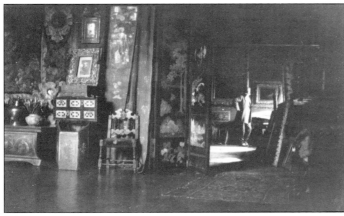

[215]

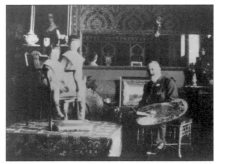

[216]

[213] 83.Stm.30
Mary Content in the doorway of
the Chase home, Shinnecock Hills,
c.1904
gelatin silver print
7 x 4³/₄

[214] 89.Stm.93
William Merritt Chase and
art class, New York School of Art,
c.1905
gelatin silver print
6 x 8, mounted on cardboard 10³/₄
x 12

[215] 89.Stm.32
Probably 303 Fifth Avenue studio,
William Merritt Chase in
background [duplicate 89.Stm.31;
89.Stm.59], c.1905
gelatin silver print
4³/₄ x 8

[216] 83.Stm.11
William Merritt Chase, with
Roland (seated), and Robert
(standing) in the artist's Chestnut
Street studio, Philadelphia
[duplicate 85.Mcr.13], c.1905
gelatin silver print
2¹/₂ x 3¹/₂

[217] 83.Stm.45
Chase's Chestnut Street studio,
Philadelphia, c.1905
gelatin silver print
2¹⁄₈ x 3¹⁄₈, mounted on board
5¹⁄₂ x 8

[218] 89.Stm.44
William Merritt Chase seated in
his Chestnut Street studio,
Philadelphia [duplicate 89.Stm.87],
c.1905
gelatin silver print
5 x 7¹⁄₈

[219] 89.Stm.88
Chase's Philadelphia studio,
c.1905
gelatin silver print
7 x 5

[220] 89.Stm.56
William Merritt Chase seated with
Roland on his lap, c.1905
gelatin silver print
7 x 5

[221] 83.Stm.75
William Merritt Chase,
Dorothy, Helen, and Roland,
Shinnecock Hills, c.1905
cyanotype
1¹⁄₂ x 1¹⁄₄, mounted on album page
14 x 11³⁄₄

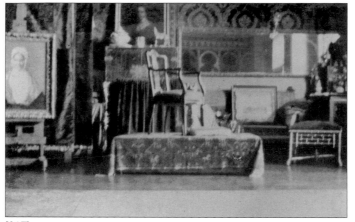

[217]

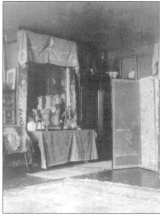

[219]

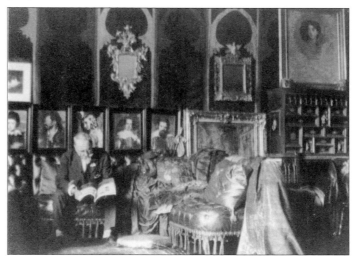

[218]

[220]

[221]

58

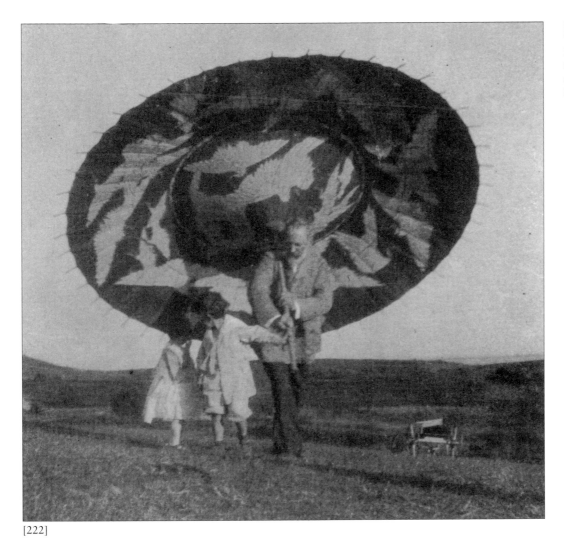

[222] 83.Stm.74
William Merritt Chase,
Mary Content, and Roland,
Shinnecock Hills, c.1905
cyanotype
$2^1/_4$ x $1^3/_8$, mounted on album page
14 x $11^3/_4$

[222]

[223] 89.Stm.19
Mrs. Chase in front of Chase
house, Shinnecock Hills, c.1905
gelatin silver print
3¼ x 2¾

[224] 76.Mc.10
Mrs. Chase (inscribed on folder:
"For/Bessie Sr. ... with love/from/
Pansies [?]/1911"), c.1905
gelatin silver print
5¾ x 3¹⁵⁄₁₆, mounted on gray
cardboard in brown folder
11½ x 8⅜

[225] 89.Stm.1
Roland and unidentified woman,
c.1905
gelatin silver print
5¼ x 3⅞

[226] 85.Mcr.16
Roland and Robert, c.1905
cyanotype
6½ x 4½

[227] 83.Stm.85
Robert as "Mercury,"
Shinnecock Hills, c.1905
cyanotype
2½ x 1⅝, mounted on album page
14 x 11¾

[228] 83.Stm.73
Roland, c.1905
cyanotype
1¾ x 1¼, mounted on album page
14 x 11¾

[223]

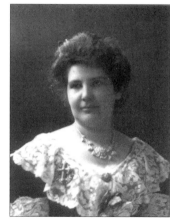

[224]

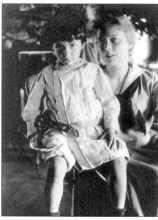

[225]

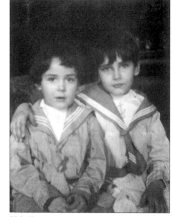

[226]

[228]

[227]

[229]

[230]

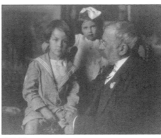

[231]

[229] 83.Stm.153
Mary Content sleeping on floor,
c.1905
gelatin printing-out paper
1½ x 2, mounted on album page
14¼ x 15¼

[230] 76.Mc.57
Mrs. Chase and possibly
Mary Content, c.1905
gelatin silver print
6⁵/₁₆ x 4½, mounted on black
board 10 x 8

[231] 83.Stm.42
Roland, Mary Content, and
William Merritt Chase, c.1906
gelatin printing-out paper
8 x 10

[232] 83.Stm.82
Alice Dieudonnée, Roland,
Mrs. Chase, Mary Content, and
family dog, Shinnecock Hills,
c.1906
cyanotype
1³/₈ x 3⅛, mounted on album page
14 x 11¾

[233] 77.Mc.20
Mary Content, Dorothy, and
Hazel, c.1906
gelatin printing-out paper
1⁷/₁₆ x 2

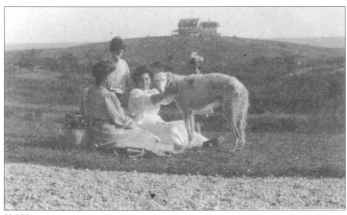

[232]

[233]

[234] 83.Stm.80
Mrs. Chase at lily pool, c.1907
cyanotype
2¼ x 3¼, mounted on album page
14 x 11¾

[235] 83.Stm.71
Dorothy, Shinnecock Hills, c.1907
cyanotype
3¼ x 2, mounted on album page
14 x 11¾

[236] 83.Stm.5
Helen, Mary Content, Roland,
and Robert looking seaward
[duplicate 76.Mc.35c], c.1907
cyanotype
2½ x 3¼

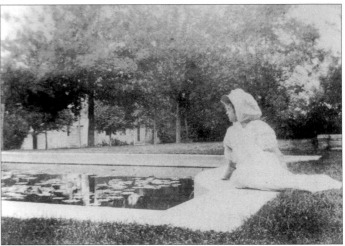

[234]

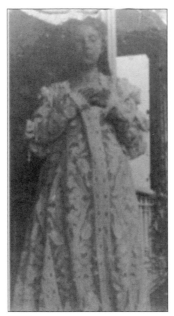

[235]

[236]

[237] 83.Stm.6
Mrs. Chase, Mary Content,
Roland, Robert, Hazel, Helen,
Dorothy, Koto and Alice
Dieudonnée, c.1907
cyanotype
2$^{1}/_{4}$ x 3$^{1}/_{2}$

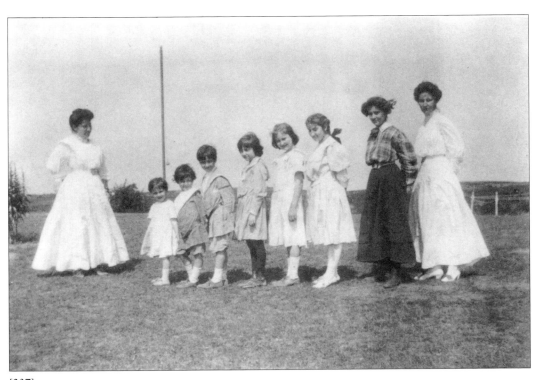

[237]

[238] 76.Mc.13c
Chase house from the front,
Shinnecock Hills, c.1908
cyanotype
2¹/₂ x 4¹/₄

[239] 76.Mc.35d
View of the southeast corner of the
front porch of the Chase home,
Shinnecock Hills, c.1908
cyanotype
2¹/₄ x 4

[240] 83.Stm.78
Alice Dieudonnée and unidentified
man in a horse drawn buggy in
front of Chase house, Shinnecock
Hills [duplicate 76.Mc.13e],
c.1908
cyanotype
4 x 2³/₈, mounted on album page
14 x 11³/₄

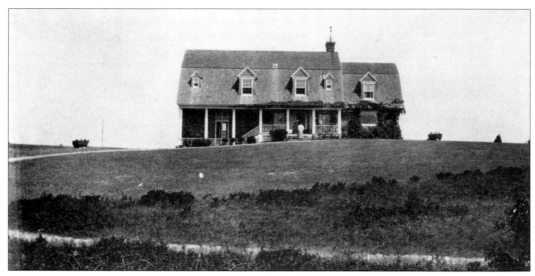

[238]

[239]

[240]

[241]

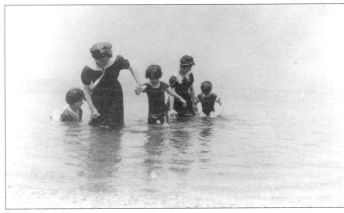

[242]

[243]

[244]

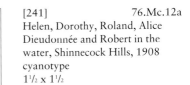

[245]

[246]

[241] 76.Mc.12a
Helen, Dorothy, Roland, Alice
Dieudonnée and Robert in the
water, Shinnecock Hills, 1908
cyanotype
1¹/₂ x 1¹/₂

[242] 76.Mc.12b
Helen, Dorothy, Roland,
Alice Dieudonnée and Robert,
Shinnecock Hills, 1908
cyanotype
2¹/₂ x 4¹/₄

[243] 76.Mc.12c
Alice Dieudonnée, Roland,
Robert, Helen, and Dorothy,
Shinnecock Hills, 1908
cyanotype
2¹/₂ x 4¹/₄

[244] 76.Mc.12d
On the beach, Shinnecock Hills,
1908
cyanotype
4¹/₄ x 2¹/₂

[245] 76.Mc.12e
Roland, Alice Dieudonnée, and
Dorothy, Shinnecock Hills, 1908
cyanotype
2¹/₂ x 4¹/₄

[246] 76.Mc.12f
The Chase family dog and Alice
Dieudonnée, Shinnecock Hills,
1908
cyanotype
2¹/₂ x 2¹/₂

[247] 76.Mc.28a
Roland and Robert dressed as
Indians, Shinnecock Hills, c.1908
cyanotype
2¼ x 3¼

[248] 76.Mc.28b
Robert and Helen dressed as
Arabs, Shinnecock Hills, c.1908
cyanotype
2¼ x 3¼

[249] 76.Mc.28c
Robert, Helen, Mary Content, and
Roland and Betty Fisher in back,
Shinnecock Hills, c.1908
cyanotype
2¼ x 3¼

[250] 76.Mc.28d
Helen, Robert, Roland, and
Mary Content in front of the Chase
house, Shinnecock Hills, c.1908
cyanotype
2¼ x 3¼

[251] 76.Mc.28e
Roland, Helen, Robert, and Mary
Content with the Chase carriage
house/barn in background,
Shinnecock Hills, c.1908
cyanotype
2¼ x 3¼

[252] 76.Mc.28f
Robert and Helen standing, Mary
Content and Roland seated in
beached boat, Shinnecock Hills,
c.1908
cyanotype
2¼ x 3¼

[253] 76.Mc.28h
Helen and Robert sitting atop a
carriage, Shinnecock Hills, c.1908
cyanotype
2¼ x 3¼

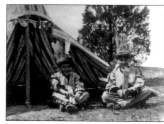

[247]

[248]

[250]

[249]

[251]

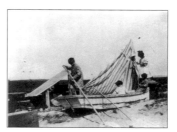

[252]

[253]

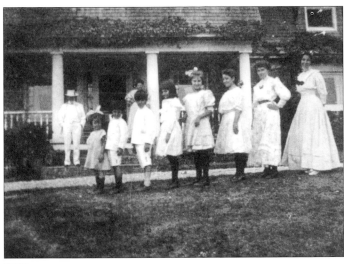

[254]

[255]

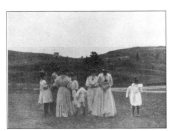

[256]

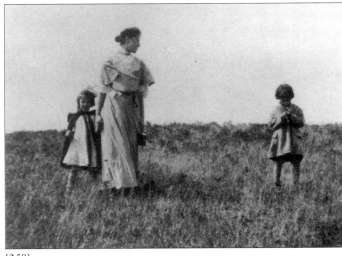

[258]

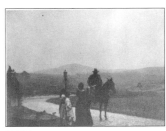

[257]

[254] 76.Mc.29a
Mary Content, Roland Dana, Robert Stewart, Hazel Neamaug, Helen Velasquez, Dorothy Brémond, Koto Robertine, and Alice Dieudonnée, with William Merritt Chase in the background, photo taken facing the front (south side) of the Chase house, Shinnecock Hills (the children are lined up in order of birth with the exception of Hazel and Helen who are reversed since Helen was so tall for her age), c.1908
cyanotype
2¼ x 3¼

[255] 76.Mc.29c
Alice Dieudonnée and unidentified young woman, leaning against the front porch columns, Chase house, Shinnecock Hills, c.1908
cyanotype
2¼ x 3¼

[256] 76.Mc.29d
Helen, unidentified woman, Mrs. Chase (back to camera), Dorothy, Robert, Koto, Alice Dieudonnée, Roland (behind Hazel), and Hazel, Shinnecock Hills, c.1908
cyanotype
2¼ x 3¼

[257] 76.Mc.29e
One of the Chase daughters, and Robert and Mrs. Chase greeting man on horseback on the front drive, Chase house, Shinnecock Hills, c.1908
cyanotype
2¼ x 3¼

[258] 76.Mc.29f
Mary Content, Betty Fisher, and Roland, Shinnecock Hills, c.1908
cyanotype
2¼ x 3¼

[259] 76.Mc.29g
Mrs. Chase, Roland, and Mary
Content, Shinnecock Hills, c.1908
cyanotype
2¹/₄ x 3¹/₄

[260] 76.Mc.89
Mrs. Chase with Helen,
Mary Content, and Robert Chase,
Shinnecock Hills, c.1908
cyanotype
2¹/₂ x 3¹/₂

[261] 76.Mc.30a
Unidentified man and Alice
Dieudonnée, Shinnecock Hills,
c.1908
cyanotype
2¹/₄ x 3¹/₄

[262] 76.Mc.30b
Alice Dieudonnée sitting in
beached boat, Shinnecock Hills,
c.1908
cyanotype
2¹/₄ x 3¹/₄

[263] 76.Mc.31b
Mary Content with the studio end
of the Chase house behind her,
Shinnecock Hills, c.1908
cyanotype
2¹/₂ x 3¹/₄

[264] 76.Mc.31c
Mary Content and Roland near
the east end of the Chase house
with the corner of the front porch
behind, Shinnecock Hills, c.1908
cyanotype
2¹/₂ x 3¹/₄

[265] 89.Stm.97
Mary Content, Shinnecock Hills
[duplicate 76.Mc.31a], c.1908
gelatin silver print
6¹/₂ x 8³/₄, mounted on cardboard
11 x 13

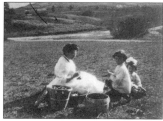

[259]

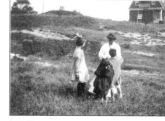

[260]

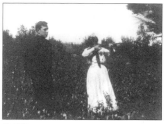

[261]

[262]

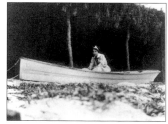

[263]

[264]

[265]

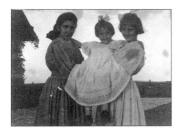

[266]

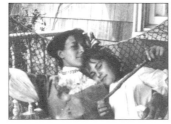

[267]

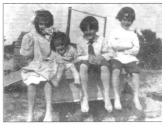

[268]

[269]

[270]

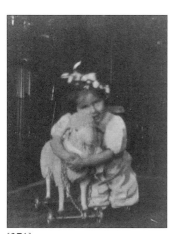

[271]

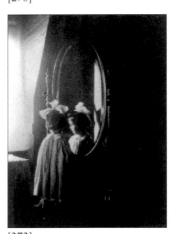

[272]

[266] 76.Mc.31d
Dorothy and Helen holding Mary
Content, Shinnecock Hills, c.1908
cyanotype
2¹/₂ x 3¹/₂

[267] 76.Mc.31e
Betty Fisher and Helen in a
hammock on the porch of the
Chase house, Shinnecock Hills,
c.1908
cyanotype
2¹/₂ x 3¹/₄

[268] 76.Mc.31f
Helen, Mary Content, Robert, and
Roland sitting on the end of a
beached boat, Shinnecock Hills,
c.1908
cyanotype
2 x 2¹/₂

[269] 76.Mc.31g
Roland and Chase family dog,
Shinnecock Hills, c.1908
cyanotype
2¹/₂ x 3¹/₄

[270] 76.Mc.32a
Possibly Mary Content,
Shinnecock Hills, c.1908
cyanotype
3¹/₄ x 2¹/₄

[271] 76.Mc.32b
Mary Content with toy lamb in
the Chase house, Shinnecock Hills,
c.1908
cyanotype
2¹/₂ x 2¹/₄

[272] 76.Mc.32c
Mary Content before a mirrror in
one of the 2nd floor bedrooms of
the Chase house, Shinnecock Hills,
c.1908
cyanotype
3¹/₄ x 2¹/₄

[273] 76.Mc.32d
Mary Content in front of the Chase
house, Shinnecock Hills, c.1908
cyanotype
3¼ x 2¼

[274] 76.Mc.32e
Mary Content, Shinnecock Hills,
c.1908
cyanotype
3¼ x 2¼

[275] 76.Mc.32f
Mary Content, Shinnecock Hills,
c.1908
cyanotype
3¼ x 2¼

[276] 76.Mc.32i
Roland and Robert on the
2nd floor west end balcony, Chase
house, Shinnecock Hills, c.1908
cyanotype
3¼ x 2½

[277] 85.Mcr.18
Robert and Roland, c.1908
gelatin silver print
9½ x 7½

[278] 76.Mc.32h
Roland petting Chase family dog,
Shinnecock Hills, c.1908
cyanotype
3¼ x 2½

[279] 76.Mc.35a
Mary Content (foreground) and
Roland and unidentified woman,
at east end of Chase house,
Shinnecock Hills, c.1908
cyanotype
2¼ x 3¼

[280] 76.Mc.35b
Mary Content (far left background)
with Arthur Sullivan and Alice
Dieudonnée with Chase carriage
house/barn in background,
Shinnecock Hills, c.1908
cyanotype
2 x 3¼

[273]

[274]

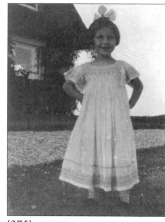
[275]

[276]

[277]

[278]

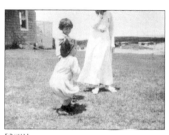
[279]

[280]

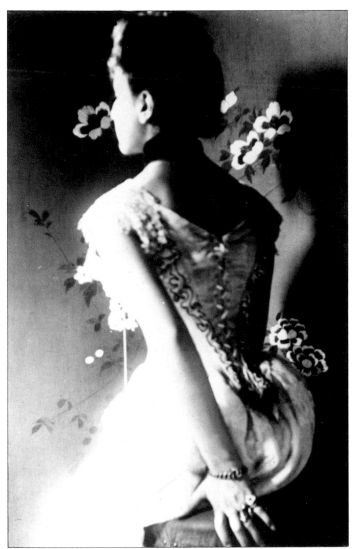

[281]

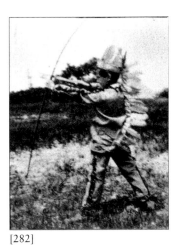

[282]

[281] 91.RGP/PS.32
Alice Dieudonnée (inscribed verso:
"Alice"), c.1908
gelatin printing-out paper
6¼ x 4

[282] 76.Mc.35g
Robert dressed as an Indian,
Shinnecock Hills, c.1908
cyanotype
2¼ x 2

[283] 89.Stm.75
William Merritt Chase in
303 Fifth Avenue studio
[duplicate 89.Stm.34], c.1909
gelatin silver print
7 x 9$\frac{1}{2}$

[284] 76.Mc.7
William Merritt Chase [duplicate
85.Mcr.8; 89.Stm.39], c.1909
gelatin silver print
7$\frac{3}{4}$ x 9$\frac{5}{8}$

[285] 89.Stm.78
William Merritt Chase, c.1909
gelatin silver print
9$\frac{3}{4}$ x 8

[286] 83.Stm.43
William Merritt Chase, c.1909
gelatin silver print
7$\frac{3}{4}$ x 5$\frac{1}{4}$

[287] 76.Mc.14a
Helen and Roland, Shinnecock
Hills, 1909
cyanotype
3$\frac{1}{4}$ x 2$\frac{1}{4}$

[288] 76.Mc.14b
Bedroom, probably Roland's,
Chase house, Shinnecock Hills,
c.1909
cyanotype
3$\frac{1}{4}$ x 2$\frac{1}{4}$

[289] 76.Mc.14c
Alice Dieudonnée, Shinnecock
Hills, 1909
cyanotype
3$\frac{1}{4}$ x 2$\frac{1}{4}$

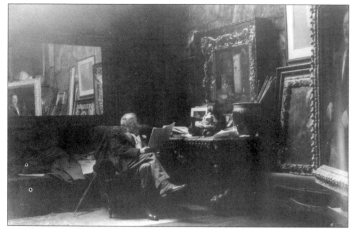
[283]

[284]

[285]

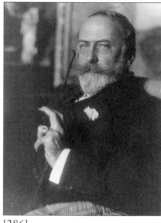
[286]

[287]

[288]

[289]

[290]

[291]

[292]

[293]

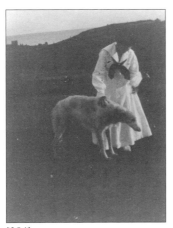

[294]

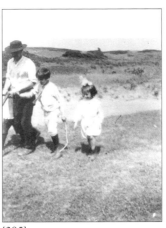

[295]

[290] 76.Mc.14d
Roland and Robert, Shinnecock
Hills, 1909
cyanotype
3¼ x 2¼

[291] 76.Mc.14e
Chase daughters with Roland and
Robert, Chase house in
background, Shinnecock Hills,
1909
cyanotype
3¼ x 2¼

[292] 76.Mc.14h
The Chase flagpole, Shinnecock
Hills, 1909
cyanotype
3¼ x 2¼

[293] 76.Mc.14f
Koto and Alice Dieudonnée
forming "London Bridge" with
Mary Content in front and Roland
behind, 1909
cyanotype
3¼ x 2¼

[294] 76.Mc.14g
The Chase family dog and Alice
Dieudonnée, 1909
cyanotype
3¼ x 2¼

[295] 76.Mc.14i
The Chase family gardener with
Roland to his right and Robert
and Mary Content to his left,
Shinnecock Hills, 1909
cyanotype
3¼ x 2¼

[296] 76.Mc.15a
Mary Content, Shinnecock Hills,
1909
cyanotype
3¼ x 2¼

[297] 76.Mc.15b
Robert, Roland, and Mary
Content, Shinnecock Hills, 1909
cyanotype
3¼ x 2¼

[298] 76.Mc.15c
Mary Content near the front
porch steps of the Chase house,
Shinnecock Hills, 1909
cyanotype
3¼ x 2¼

[299] 76.Mc.15d
Roland, Robert, and Mary
Content, Shinnecock Hills, 1909
cyanotype
2¼ x 3¼

[300] 76.Mc.15e
Roland, Mary Content, and
Robert in front of one of the two
whaling pots that flanked the
Chase house, Shinnecock Hills,
1909
cyanotype
2¼ x 3¼

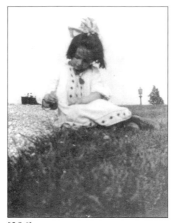

[296]

[297]

[298]

[299]

[300]

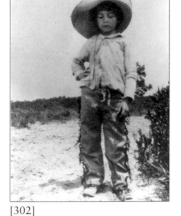

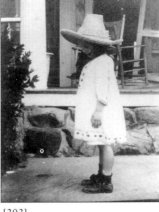

[301]

[302]

[303]

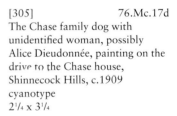

[304]

[305]

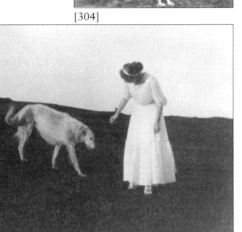

[306]

[301] 76.Mc.15f
Mary Content on the front steps of
the Chase house, Shinnecock Hills,
1909
cyanotype
3¼ x 2¼

[302] 76.Mc.15g
Roland in cowboy costume,
Shinnecock Hills, 1909
cyanotype
3¼ x 2¼

[303] 76.Mc.15h
Mary Content in straw hat on
stoop of front porch, Chase house,
Shinnecock Hills, 1909
cyanotype
3¼ x 2¼

[304] 76.Mc.17c
The Chase family dog with the
drive to the house behind and the
two lamps (now only the bases
remain), Shinnecock Hills, c.1909
cyanotype
2¼ x 3¼

[305] 76.Mc.17d
The Chase family dog with
unidentified woman, possibly
Alice Dieudonnée, painting on the
drive to the Chase house,
Shinnecock Hills, c.1909
cyanotype
2¼ x 3¼

[306] 76.Mc.17a
The Chase family dog,
probably with Alice Dieudonnée,
Shinnecock Hills, 1909
cyanotype
2¼ x 3¼

[307] 76.Mc.17g
Mary Content, Helen, Roland,
Alice Dieudonnée, and Robert in
the backyard area of the Chase
house, Shinnecock Hills, c.1909
cyanotype
2¹/₄ x 3¹/₄

[308] 76.Mc.17h
Alice Dieudonnée and unidentified
young woman in the dunes,
Shinnecock Hills, c.1909
cyanotype
2¹/₄ x 3¹/₄

[309] 76.Mc.17e
Roland, Robert, Alice Dieudonnée,
Helen, and Mary Content in the
back of the Chase house, with
carriage house on the right in
background, Shinnecock Hills,
1909
cyanotype
2¹/₄ x 3¹/₄

[310] 76.Mc.75
Arthur Sullivan and
Mary Content Chase
cyanotype
2 x 2¹¹/₁₆, printed on penny
postcard 5¹/₂ x 3¹/₂, postmarked
Aug. 1909, Shinnecock, NY,
with note from Sita[?] to
Elizabeth Fisher

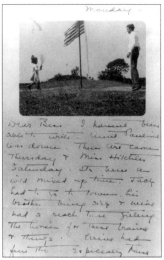

[310]

[307]

[308]

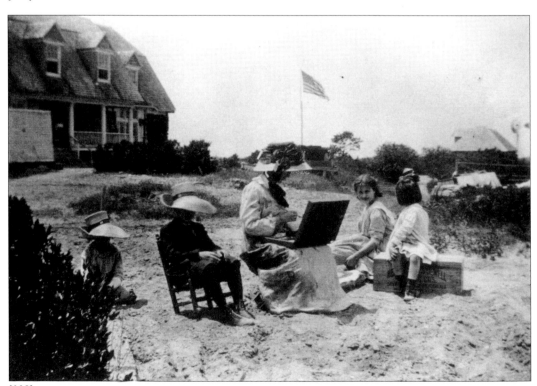

[309]

[311]

[312]

[313]

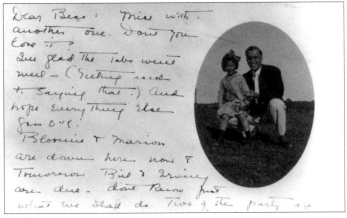

[315]

[314]

[311] 76.Mc.76
Robert, Helen, Roland, Dorothy, Mary Content, and Hazel (seated l. to r.); Mrs. Wadsworth and Alice Dieudonnée standing, Shinnecock Hills
cyanotype
2 x 2$^{11/16}$, printed on penny postcard 5$^{1/2}$ x 3$^{1/2}$, postmarked Sept. 10, 1909, Brooklyn, N.Y., with note from "Sita" to Miss Fisher: "Dot's birthday...assembled family plus Mrs. Wadsworth."

[312] 76.Mc.77
Arthur Sullivan, Alice Dieudonnée, Koto and Kenneth Carr (l. to r.)
cyanotype
2 x 2$^{11/16}$, printed on penny postcard 5$^{1/2}$ x 3$^{1/2}$, postmarked Sept. 7, 1909, Shinnecock, N.Y., with note from "Sita" to Miss Fisher

[313] 76.Mc.78
Mrs. Chase and unidentified woman in Saint Mark's Square, Venice
cyanotype
2 x 2$^{11/16}$, printed on penny postcard 5$^{1/2}$ x 3$^{1/2}$, postmarked Sept. 9, 1909, Shinnecock, N.Y., with note to Miss Fisher

[314] 76.Mc.79
Chase house, Shinnecock Hills
cyanotype
3$^{7/16}$ x 3$^{3/8}$, printed on penny postcard 3$^{1/3}$ x 5$^{1/2}$, postmarked Sept. 10, 1909, with note from "Lady Pansies" [Mrs.Chase] to Miss Bessie Fisher, requesting "...brown liquid to photograph, or rather print with. I want it for a scheme I have."

[315] 76.Mc.80
Mary Content and Arthur Sullivan
cyanotype
2$^{5/8}$ x 2, oval format, printed on postcard 3$^{1/3}$ x 5$^{1/2}$, postmarked Sept. 3, 1909, Shinnecock, N.Y., with note from "Sita" to Miss Fisher

[316] 83.Stm.169
Roland, Shinnecock Hills, c.1903
gelatin printing-out paper
2 x 1 1/4, mounted on album page
14 1/4 x 15 1/4

[317] 83.Stm.165
Roland, Shinnecock Hills, c.1903
gelatin printing-out paper
2 1/2 x 2, mounted on album page
14 1/4 x 15 1/4

[318] 83.Stm.161
Two unidentified children in
kimonos, c.1903
gelatin printing-out paper
1 5/8 x 1, mounted on album page
14 1/4 x 15 1/4

[319] 83.Stm.46
Chase's Chestnut Street studio,
Philadelphia, c.1905
gelatin silver print
2 1/8 x 3 1/8

[320] 85.Mcr.13
William Merritt Chase in his
Chestnut Street studio,
Philadelphia, with Roland
(seated) and Robert (standing)
[duplicate 83.Stm.11], c.1905
gelatin printing-out paper
2 1/4 x 3 1/4

[321] 89.Stm.31
Probably 303 Fifth Avenue studio,
William Merritt Chase in
background [duplicate 89.Stm.32;
89.Stm.59], c.1905
gelatin silver print
4 1/2 x 7

[322] 89.Stm.59
Probably Chase's 303 Fifth Avenue
studio, William Merritt Chase
standing in background [duplicate
89.Stm.31; 89.Stm.32], c.1905
gelatin silver print
5 x 7

[323] 89.Stm.87
William Merritt Chase seated in
his Chestnut Street studio,
Philadelphia [duplicate 89.Stm.44],
c.1905
gelatin silver print
4 7/8 x 7

[324] 89.Stm.52
William Merritt Chase with
Roland (seated), Robert (standing),
Chase's Shinnecock landscape,
lower right corner, in Chase's
Chestnut Street studio [duplicate
89.Stm.45], c.1905
gelatin silver print
5 x 7

[325] 76.Mc.56
Mrs. Chase and possibly
Mary Content, c.1905
gelatin silver print
4 1/2 x 6 3/4, mounted on black board
10 x 8

[326] 83.Stm.83
Roland, Shinnecock Hills, c.1904
cyanotype
3 1/2 x 2 1/2, mounted on album page
14 x 11 3/4

[327] 83.Stm.81
First Presbyterian Church,
Meeting House Lane and South
Main Street, Southampton, c.1905
cyanotype
3 1/4 x 3 1/4, mounted on album page
14 x 11 3/4

[328] 83.Stm.69
Roland and Robert, c.1905
cyanotype
2 1/2 x 3 1/4, mounted on album page
14 x 11 3/4

[329] 83.Stm.68
Outbuildings, Chase houses,
Shinnecock Hills, c.1905
cyanotype
2 3/4 x 2 1/2, mounted on album page
14 x 11 3/4

[330] 83.Stm.86
Unidentified man, c.1905
cyanotype
2 5/8 x 1 1/4, mounted on album page
14 x 11 3/4

[331] 76.Mc.13e
Alice Dieudonnée and unidentified
man in a horse drawn buggy
in front of the Chase house
[duplicate 83.Stm.78], Shinnecock
Hills, c.1908
cyanotype
2 1/2 x 4 1/4

[332] 76.Mc.31a
Mary Content, with the drive to
the Chase house in the
background, Shinnecock Hills
[duplicate 89.Stm.97], c.1908
cyanotype
2 1/2 x 3 1/2

[333] 76.Mc.29b
Unidentified young woman, with
Chase family dog in front of porch
of Chase house, Shinnecock Hills,
c.1908
cyanotype
2 1/4 x 3 1/4

[334] 76.Mc.12g
Roland, Alice Dieudonnée, Robert,
and Helen, Shinnecock Hills, 1908
cyanotype
2 1/2 x 4 1/4

[335] 76.Mc.13a
Unidentified figure in silhouette,
c.1908
cyanotype
2 1/2 x 4 1/4

[336] 76.Mc.13b
Evening landscape, Shinnecock
Hills, c.1908
cyanotype
4 1/4 x 2 1/2

[337] 76.Mc.13d
The Chase family dog on the old
sand road, Shinnecock Hills,
c.1908
cyanotype
2 1/2 x 4 1/4

[338] 76.Mc.30c
Unidentified figures seated on a
carriage, Shinnecock Hills, c.1908
cyanotype
2 1/4 x 3 1/4

[339] 76.Mc.30d
Unidentified figure on a carriage,
Shinnecock Hills, c.1908
cyanotype
2 1/4 x 3 1/4

[340] 76.Mc.30e
Unidentified woman and
Alice Dieudonnée in the dunes,
Shinnecock Hills, c.1908
cyanotype
2 1/4 x 3 1/4

[341] 76.Mc.30f
Three young women (probably
Alice Dieudonnée at far right),
Shinnecock Hills, c.1908
cyanotype
2 1/4 x 3 1/4

[342] 76.Mc.30h
Unidentified figures in a carriage,
Shinnecock Hills, c.1908
cyanotype
2 1/4 x 3 1/4

[343] 76.Mc.32g
Roland with Chase family dog,
Shinnecock Hills, c.1908
cyanotype
3 1/4 x 2 1/2

[344] 76.Mc.28g
Roland and Chase family dog,
Shinnecock Hills, c.1908
cyanotype
2 1/4 x 3 1/4

[345] 76.Mc.17f
Unidentified young woman and
Alice Dieudonnée seated,
Shinnecock Hills, c.1909
cyanotype
2¹/₄ x 3¹/₄

[346] 76.Mc.17b
The Chase family dog with
unidentified woman painting on
the front drive, Shinnecock Hills,
1909
cyanotype
2¹/₄ x 3¹/₄

[347] 83.Stm.84
Horse and carriage in front of
Chase home, Shinnecock Hills,
c.1908
cyanotype
2¹/₂ x 4¹/₄, mounted on album page
14 x 11³/₄

[348] 89.Stm.34
William Merritt Chase in 303
Fifth Avenue studio, with his
PORTRAIT OF EMIL PAUR
reflected in mirror in background
[duplicate 89.Stm.75], c.1909
gelatin silver print
7 x 9³/₄

[349] 85.Mcr.8
William Merritt Chase [duplicate
76.Mc.7; 89.Stm.79], c.1909
gelatin silver print
7¹/₄ x 9¹/₈

[350] 89.Stm.39
William Merritt Chase
[duplicate 76.Mc.7; 85.Mcr.8],
(inscribed verso: "Wm.M.Chase/
I made this and Mr. Chase/liked it
better than any other."), c.1909
gelatin silver print
8 x 9¹/₂

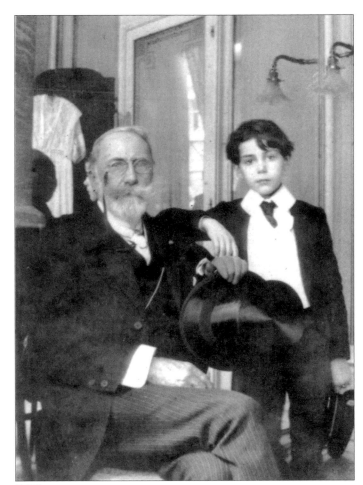

[351]

[352]

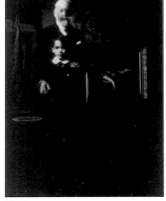

[353]

Shinnecock Hills
1910

[351] 89.Stm.15
William Merritt Chase and Roland,
c.1910
gelatin silver print
2¹/₂ x 1⁵/₈

[352] 83.Stm.18
William Merritt Chase and Robert
with large fish still life on easel,
c.1910
gelatin silver print
3¹/₂ x 2³/₄

[353] 89.Stm.10
William Merritt Chase and Robert
with large fish still life on easel,
c.1910
gelatin silver print
4 x 3

[354] 89.Stm.53
Mrs. Chase seated, Chase pastel of
MEDITATION and other
paintings hanging behind, c.1910
gelatin silver print
3¼ x 3¼

[355] 89.Stm.65
Mrs. Chase seated with one of
their pet dogs, c.1910
cyanotype
2¾ x 3½

[356] 76.Mc.39a
Mrs.Chase, c.1910
gelatin silver print
3⁷⁄₁₆ x 3⁷⁄₁₆, mounted on black
board 10 x 8

[357] 76.Mc.40
Mrs.Chase, c.1910
gelatin silver print
5 x 3½, mounted on black board
10 x 8

[358] 76.Mc.41
Mrs.Chase, c.1910
gelatin silver print
5⅝ x 3⅞, mounted on black
board 10 x 8

[359] 76.Mc.6
Mrs. Chase (photograph cut into
round shape), c.1910
gelatin silver print
2 inch diameter

[355]

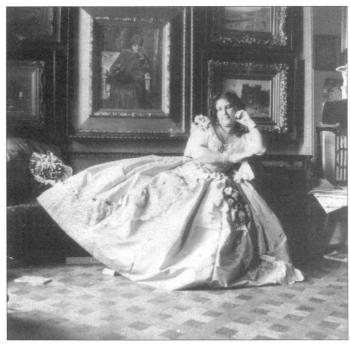

[354]

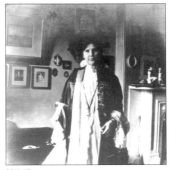

[356]

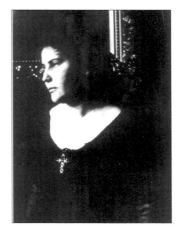

[357]

[358]

[359]

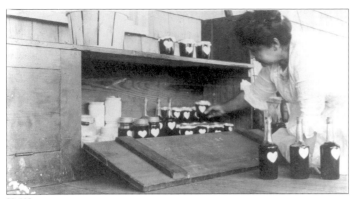

[360]

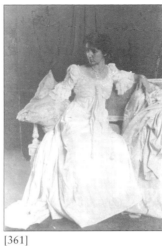

[361]

[360] 89.Stm.22
Mrs. Chase putting away
preserves, Shinnecock Hills,
c.1910
gelatin silver print
3¼ x 5½

[361] 89.Stm.89
Alice Dieudonnée, c.1910
gelatin silver print
6¾ x 4¾

[362] 89.Stm.26
Arthur Sullivan and Alice
Dieudonnée with Chase pastel
MEDITATION hanging in
background, 15th Street house,
c.1910
gelatin silver print
4½ x 6⅜

[362]

[363] 76.Mc.18a
Robert, Helen, Dorothy, Koto,
Alice Dieudonnée, her fiancé
Arthur Sullivan, and Mary Content
in front of the Chase house,
Shinnecock Hills, 1910
cyanotype
2¹/₂ x 3¹/₄

[364] 76.Mc.18c
Robert, Mary Content, Alice
Dieudonnée, and Roland,
Shinnecock Hills, 1910
cyanotype
2¹/₄ x 3¹/₄

[365] 76.Mc.18d
Alice Dieudonnée, Mary Content,
Robert, Dorothy, and Roland
playing, Shinnecock Hills, 1910
cyanotype
2¹/₄ x 3¹/₄

[366] 76.Mc.18i
Mary Content in back left, Helen,
Robert, and Roland, on the studio
end of the Chase house,
Shinnecock Hills, 1910
cyanotype
2¹/₄ x 3¹/₄

[367] 76.Mc.18f
Mary Content with her collection
of dolls, on the front steps of the
Chase house, Shinnecock Hills,
1910
cyanotype
3¹/₄ x 2¹/₄

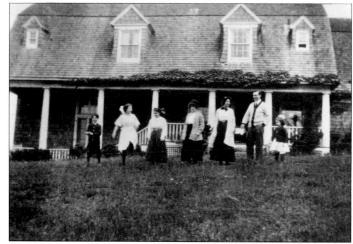
[363]

[364]

[365]

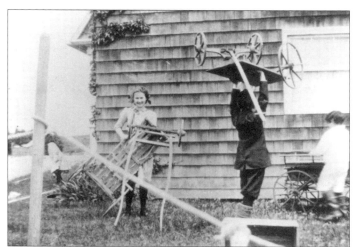
[366]

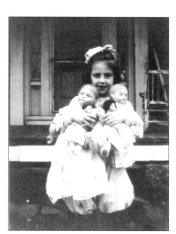
[367]

[368]

[368] 76.Mc.18e
Roland and Robert over the
barrel, Shinnecock Hills, 1910
cyanotype
3¹/₄ x 2¹/₄

[369] 76.Mc.19a
Helen, Dorothy, possibly Betty
Fisher, Arthur Sullivan, and Fran
Sullivan, Shinnecock Hills, 1910
cyanotype
2¼ x 4¼

[370] 76.Mc.19b
Alice Dieudonnée and Arthur
Sullivan, Shinnecock Hills, 1910
cyanotype
4¼ x 2½

[371] 76.Mc.19c
Robert, Helen, possibly Betty
Fisher, Dorothy, and Roland,
Shinnecock Hills, 1910
cyanotype
2½ x 4¼

[372] 76.Mc.19d
Robert and Roland, Shinnecock
Hills, 1910
cyanotype
2½ x 2½

[373] 76.Mc.20a
Mrs. Fisher and Mrs. Chase
crocheting, Shinnecock Hills, 1910
cyanotype
2¼ x 2¼

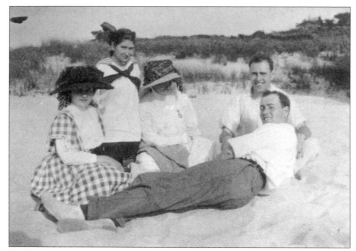
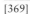

[369]

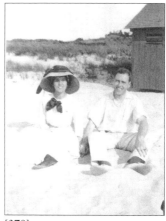

[370]

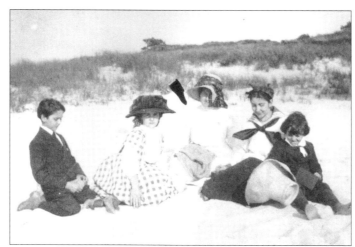

[371]

[372]

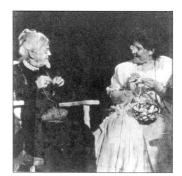

[373]

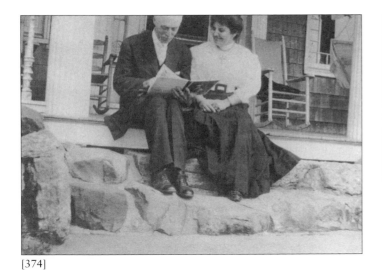

[374]

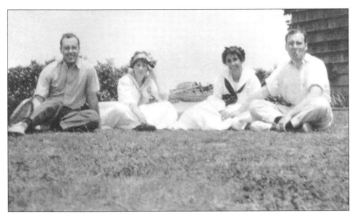

[376]

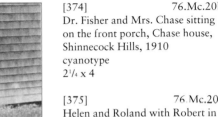

[375]

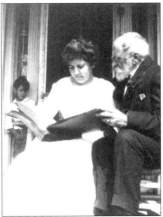

[377]

[378]

[374] 76.Mc.20b
Dr. Fisher and Mrs. Chase sitting
on the front porch, Chase house,
Shinnecock Hills, 1910
cyanotype
2¼ x 4

[375] 76.Mc.20c
Helen and Roland with Robert in
barrel, in front of west wall of
Shinnecock studio, 1910
cyanotype
2¼ x 2¼

[376] 76.Mc.20f
Francis Sullivan, Koto, Alice
Dieudonnée, and Arthur Sullivan,
Shinnecock Hills, 1910
cyanotype
2¼ x 4

[377] 76.Mc.20e
Roland in back left, Mrs. Chase
and William Merritt Chase
looking at album on front steps of
Shinnecock Hills house, 1910
cyanotype
2¼ x 3¼

[378] 76.Mc.20d
Mrs. Chase bleaching linen on the
front lawn, Shinnecock Hills,
1910
cyanotype
2¼ x 4

[379] 76.Mc.20g
Mary Content, Roland, Helen,
and Robert, Shinnecock Hills,
1910
cyanotype
2$\frac{1}{4}$ x 3$\frac{1}{4}$

[380] 76.Mc.20h
Robert, Roland, unidentified
woman, and Mrs. Chase in front
of the Chase house, Shinnecock
Hills, 1910
cyanotype
2$\frac{1}{4}$ x 3$\frac{1}{4}$

[381] 76.Mc.21a
Robert, Roland, and Mary
Content, Shinnecock Hills, 1910
cyanotype
3$\frac{1}{4}$ x 3$\frac{1}{2}$

[382] 76.Mc.21b
Robert, Roland, and Mary
Content, Shinnecock Hills, 1910
cyanotype
3$\frac{1}{4}$ x 3$\frac{1}{2}$

[383] 76.Mc.21c
Roland with Mary Content in
background, Shinnecock Hills,
1910
cyanotype
3$\frac{1}{4}$ x 3$\frac{1}{2}$

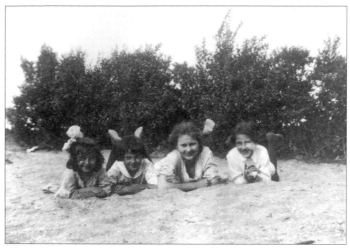
[379]

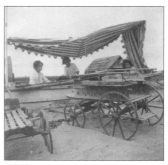
[381]

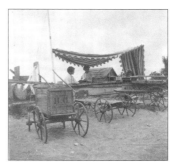
[382]

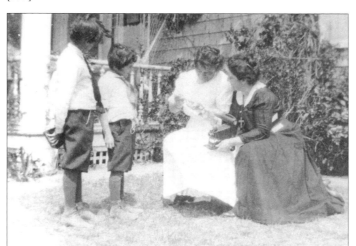
[380]

[383]

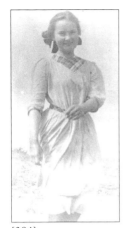

[384]

[385]

[386]

[387]

[384] 76.Mc.22a
Helen, Shinnecock Hills, 1910
cyanotype
4^1/$_4$ x 2^1/$_4$

[385] 76.Mc.22c
Robert, Shinnecock Hills, 1910
cyanotype
4^1/$_4$ x 2^1/$_4$

[386] 76.Mc.22b
Koto, Shinnecock Hills, 1910
cyanotype
4^1/$_4$ x 2^1/$_4$

[387] 76.Mc.22d
Helen and Mary Content,
Shinnecock Hills, 1910
cyanotype
3^1/$_4$ x 2^1/$_4$

[388] 76.Mc.22e
Koto, Shinnecock Hills, 1910
cyanotype
3¼ x 2¼

[389] 76.Mc.22f
Roland with the Chase family dog,
Shinnecock Hills, 1910
cyanotype
3¼ x 2¼

[390] 76.Mc.22g
Helen, Shinnecock Hills, 1910
cyanotype
2¼ x 2¼

[391] 76.Mc.22h
Koto, Shinnecock Hills, 1910
cyanotype
2¼ x 2¼

[392] 76.Mc.22i
Roland, Shinnecock Hills, 1910
cyanotype
2¼ x 2½

[393] 76.Mc.23a
Mary Content in front of the
Chase house, Shinnecock Hills,
c.1910
cyanotype
5 x 3¼

[394] 76.Mc.23c
Arthur Sullivan with camera,
Shinnecock Hills, c.1910
cyanotype
2½ x 1¼

[395] 76.Mc.23d
William Merritt Chase walking
with daughter Mary Content,
Shinnecock Hills, c.1910
cyanotype
2½ x 2¼

[396] 76.Mc.23f
Mary Content on the old sand
road, Shinnecock Hills, c.1910
cyanotype
3¼ x 2¼

[388]

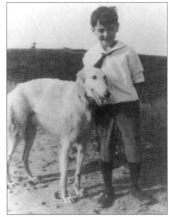

[389]

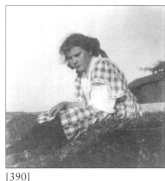

[390]

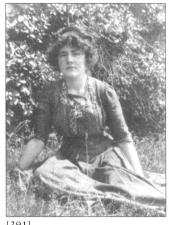

[391]

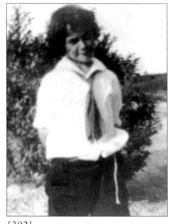

[392]

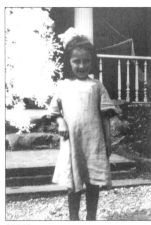

[393]

[394]

[395]

[396]

[397]

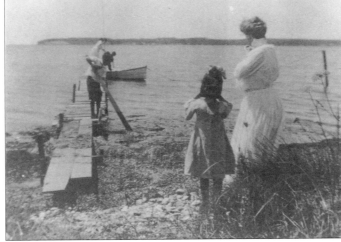

[398]

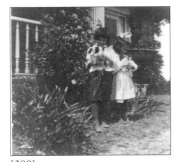

[399]

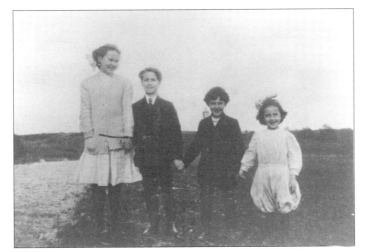

[400]

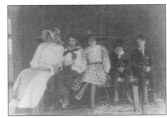

[401]

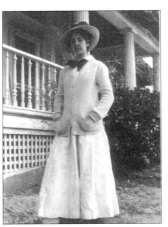

[402]

[397] 76.Mc.23h
Mary Content on the old sand
road, Shinnecock Hills, c.1910
cyanotype
2¼ x 3¼

[398] 76.Mc.23i
Robert on pier, with Mary Content
and unidentified female figure on
shore, probably Shinnecock Bay,
c.1910
cyanotype
2¼ x 3¼

[399] 76.Mc.24c
Roland and Mary Content in front
of the porch of the Chase house,
Shinnecock Hills, 1910
cyanotype
2¼ x 2¼

[400] 76.Mc.24e
Helen, Robert, Roland, and
Mary Content holding hands,
Shinnecock Hills, 1910
cyanotype
2¼ x 3¼

[401] 76.Mc.24f
Possibly Betty Fisher, Dorothy,
Helen, Roland, and Robert seated,
Shinnecock Hills, 1910
cyanotype
2¼ x 3¼

[402] 76.Mc.33a
Alice Dieudonnée in front of the
Chase house, Shinnecock Hills,
c.1910
cyanotype
3¼ x 2¼

[403] 76.Mc.33b
Mrs. Chase and Alice Dieudonnée
in front of the Chase house,
showing the doors leading to the
studio on the left, Shinnecock Hills,
c.1910
cyanotype
3¼ x 2¼

[404] 76.Mc.33c
Alice Dieudonnée sitting on the
front steps of the Chase house,
Shinnecock Hills, c.1910
cyanotype
3¼ x 2¼

[405] 76.Mc.33d
Alice Dieudonnée with horse,
Shinnecock Hills, c.1910
cyanotype
3¼ x 2¼

[406] 76.Mc.33e
Roland on the west end of the
front porch, Shinnecock Hills,
c.1910
cyanotype
3½ x 2¼

[407] 76.Mc.13f
Roland in uniform, c.1910
cyanotype
4¼ x 2½

[403]

[404]

[405]

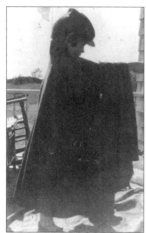

[406]

[407]

[408]

[409]

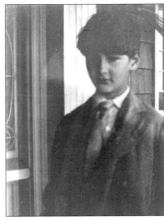

[410]

[412]

[411]

[408] 76.Mc.33f
Mary Content seated at table with
one of her dolls, Shinnecock Hills,
c.1910
cyantoype
3¹/₄ x 2¹/₄

[409] 76.Mc.33g
Robert standing on the front
porch, Shinnecock Hills, c.1910
cyanotype
3¹/₄ x 2¹/₄

[410] 76.Mc.33i
Robert on the porch in front of the
front door, Chase house,
Shinnecock Hills, c.1910
cyanotype
3¹/₄ x 2¹/₄

[411] 76.Mc.33h
William Merritt Chase and Roland
standing on the west end of the
front porch with the door to the
studio on the right, Shinnecock
Hills, c.1910
cyanotype
3¹/₄ x 2¹/₄

[412] 89.Stm.7
Dorothy, Shinnecock Hills, c.1910
gelatin silver print
4¹/₂ x 2¹/₂

[413] 76.Mc.34a
Alice Dieudonnée sitting on the
front porch, Shinnecock Hills,
c.1910
cyanotype
3¹/₄ x 2¹/₄

[414] 76.Mc.34b
Alice Dieudonnée sitting on the
front porch, Shinnecock Hills,
c.1910
cyanotype
3¹/₄ x 2¹/₄

[415] 76.Mc.34c
Alice Dieudonnée in front of the
Chase house, Shinnecock Hills,
c.1910
cyanotype
3¹/₄ x 2¹/₄

[416] 76.Mc.34d
Alice Dieudonneé in silhouette
standing in the doorway leading to
the 2nd floor balcony at the west
end of the house, Shinnecock Hills,
c.1910
cyanotype
3¹/₄ x 2¹/₄

[413]

[414]

[415]

[416]

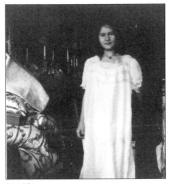

[417]

[417] 76.Mc.34h
Koto, Shinnecock Hills, c.1910
cyanotype
2¹/₄ x 2¹/₄

[418] 76.Mc.34i
Koto standing on the front porch,
Shinnecock Hills, c.1910
cyanotype
2¹/₄ x 3¹/₄

Unillustrated

[419] 76.Mc.21e
Houses set in the dunes, evening,
Shinnecock Hills, 1910
cyanotype
3¹/₄ x 3¹/₂

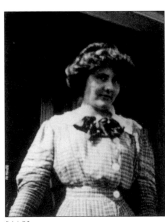

[418]

[420] 76.Mc.21f
The dunes at Shinnecock Hills,
evening, 1910
cyanotype
3¹/₄ x 3¹/₂

[421] 76.Mc.24d
Roland, Robert, and Mary Content
playing under an awning,
Shinnecock Hills, 1910
cyanotype
2¹/₄ x 2¹/₄

[422] 76.Mc.24a
Mrs. Chase and Alice Dieudonnée,
Shinnecock Hills, 1910
cyanotype
2¹/₄ x 1¹/₂

[423] 76.Mc.24b
Unidentified woman wading in the
bay, Shinnecock, 1910
cyanotype
3¹/₄ x 5¹/₂

[424] 76.Mc.23g
Mary Content, Shinnecock Hills,
c.1910
cyanotype
2¹/₄ x 3¹/₄

[425] 76.Mc.18b
Mary Content and group of
Chase children (see 76.Mc.18a)
in front of the Chase house,
Shinnecock Hills, 1910
cyanotype
2¹/₄ x 3¹/₄

[426] 76.Mc.21d
Roland, Robert, Mary Content,
Helen, and Dorothy, Shinnecock
Hills, 1910
cyanotype
3¹/₄ x 3¹/₂

[427] 76.Mc.18g
Alice Dieudonnée, Shinnecock
Hills, 1910
cyanotype
3¹/₄ x 2¹/₄

[428] 76.Mc.18h
Unidentified women with Robert
in the barrel and Roland outside,
1910
cyanotype
2¹/₄ x 3¹/₄

[429] 76.Mc.19e
Kenneth Carr (standing),
Koto, Alice Dieudonnée, and
Arthur Sullivan on the lawn,
Shinnecock Hills, 1910
cyanotype
2¹/₂ x 4¹/₄

[430] 76.Mc.19f
Helen, Arthur Sullivan, Betty
Fisher, Robert, possibly Koto, and
Dorothy on the front lawn,
Shinnecock Hills, 1910
cyanotype
2¹/₂ x 4¹/₄

[431] 76.Mc.19g
Robert, Shinnecock Hills, 1910
cyanotype
3¹/₄ x 2¹/₄

[432] 76.Mc.23b
The family playing catch: Alice
Dieudonnée to far left, Mrs. Chase,
Robert in distance, unidentified
man, probably Arthur Sullivan, in
front, Roland in mid-distance, and
Mary Content, Shinnecock Hills,
c.1910
cyanotype
2¹/₂ x 3¹/₄

[433] 76.Mc.23e
Mrs. Chase with Mary Content in
front of her, Shinnecock Hills,
c.1910
cyanotype
3¹/₄ x 2¹/₄

[434] 76.Mc.24g
Robert, Roland, Mary Content,
Helen, and Dorothy, Shinnecock
Hills, 1910
cyanotype
3¹/₂ x 3¹/₂

[435] 83.Stm.79
Alice Dieudonnée, Shinnecock
Hills, c.1910
cyanotype
3¹/₈ x 4¹/₄, mounted on album page
14 x 11³/₄

[436] 83.Stm./6
Alice Dieudonnée, Shinnecock Hills
[duplicate 76.Mc.34e], c.1910
cyanotype
3¹/₄ x 2¹/₄, mounted on album page
14 x 11³/₄

[437] 76.Mc.34e
Alice Dieudonnée, Shinnecock Hills
[duplicate 83.Stm.76], c.1910
cyanotype
3¹/₄ x 2¹/₄

[438] 83.Stm.72
Alice Dieudonnée, Shinnecock Hills
[duplicate 76.Mc.34f], c.1910
cyanotype
3¹/₄ x 2¹/₄, mounted on album page
14 x 11³/₄

[439] 76.Mc.34f
Alice Dieudonnée, Shinnecock Hills
[duplicate 83.Stm.72], c.1910
cyanotype
3¹/₄ x 2¹/₄

[440] 76.Mc.34g
Unidentified woman, Shinnecock
Hills, c.1910
cyanotype
2¹/₄ x 2¹/₄

[441] 76.Mc.35e
Alice Dieudonnée and Arthur
Sullivan boating, Shinnecock Hills,
c.1908
cyanotype
2¹/₄ x 2¹/₂

[442] 76.Mc.35f
Arthur Sullivan and Alice
Dieudonnée, Shinnecock Hills,
c.1908
cyanotype
2¹/₄ x 2¹/₄

*Florence · Venice · London ·
Carmel-by-the-Sea*
1911 *through* 1916

[443] 83.Stm.29
Mr. and Mrs. William Merritt
Chase [duplicate 89.Stm.8;
89.Stm.9], c.1911
gelatin silver print
3⁷/₈ x 5³/₄

[444] 83.Stm.101
Mr. and Mrs. Chase in pony cart,
c.1911
cyanotype
2¹/₂ x 3³/₄, mounted on album page
14 x 11³/₄

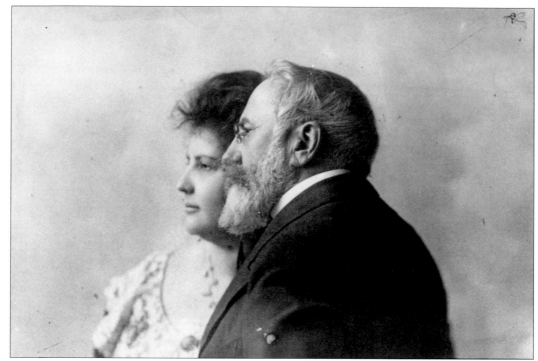

[443]

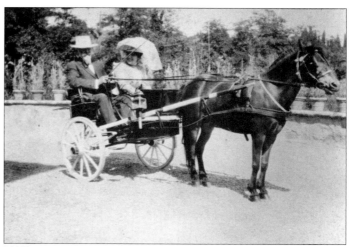

[444]

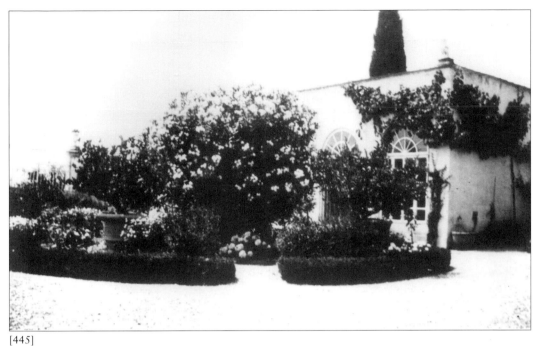

[445]

[445] 83.Stm.38
Chase's villa in Florence, c.1911
gelatin silver print
4$\frac{1}{2}$ x 7$\frac{1}{2}$

[446] 83.Stm.24
William Merritt Chase, Florence,
c.1911
gelatin silver print
5$\frac{5}{8}$ x 3$\frac{5}{8}$

[447] 83.Stm.103
Mrs. Chase in front of oleander
bush, Florence, c.1911
cyanotype
4$\frac{1}{4}$ x 2$\frac{1}{2}$, mounted on album page
14 x 11$\frac{3}{4}$

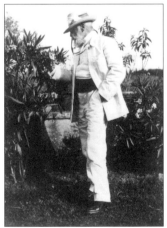

[446] [447]

[448] 83.Stm.7
William Merritt Chase with
pet dog, Florence, c.1911
gelatin silver print
2¹/₄ x 3¹/₄

[449] 83.Stm.12
William Merritt Chase bartering
for collectible items, Italy, c.1911
gelatin silver print
3¹/₄ x 4

[450] 83.Stm.105
Chase villa, Florence, c.1911
cyanotype
2¹/₂ x 4¹/₄, mounted on album page
14 x 11³/₄

[448]

[449]

[450]

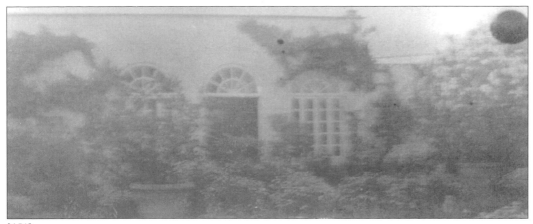

[451]

[452]

[453]

[454]

[451] 83.Stm.112
Facade of Chase villa, c.1911
cyanotype
2¼ x 4¼, mounted on album page
14 x 11¾

[452] 83.Stm.93
Doorway, Florence, c.1911
cyanotype
3⅞ x 1½, mounted on album page
14 x 11¾

[453] 83.Stm.98
Interior with chair and window,
Florence, c.1911
cyanotype
4¼ x 2½, mounted on album page
14 x 11¾

[454] 83.Stm.90
View of Florence, c.1911
cyanotype
2½ x 4¼, mounted on album page
14 x 11¾

[455] 89.Stm.61
Mrs. Chase standing in front of
old European church, probably
Italy, c.1911
gelatin silver print
4^1/$_2$ x 2^3/$_4$

[456] 76.Mc.26a
Mrs. Chase, probably at the
Fisher's home, Swiftwater, PA,
1911
cyanotype
3^1/$_4$ x 2^1/$_4$

[457] 76.Mc.26b
Mrs. Chase, probably at the
Fisher's home, Swiftwater, PA,
1911
cyanotype
3^1/$_4$ x 2^1/$_4$

[458] 76.Mc.26c
Roland, probably Swiftwater, PA,
1911
cyanotype
3^1/$_4$ x 2^1/$_4$

[459] 83.Stm.113
Steamship LUSITANIA, c.1912
gelatin printing-out paper
2^1/$_8$ x 5^1/$_2$, mounted on album page
11^3/$_4$ x 14^1/$_2$

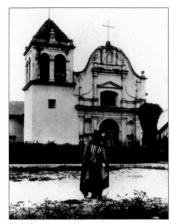

[455]

[456]

[457]

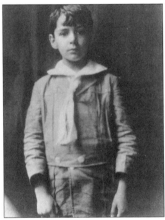

[458]

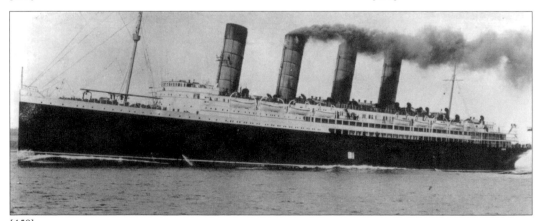

[459]

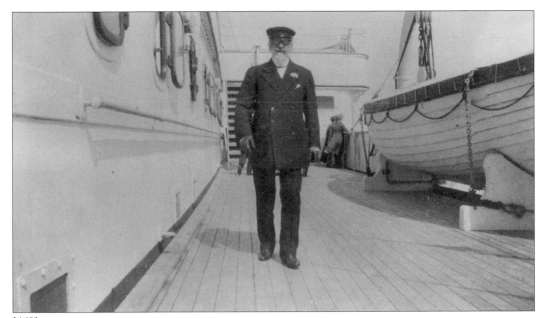

[460]

[460] 83.Stm.120
William Merritt Chase on deck of
the LUSITANIA, c.1912
cyanotype
2¹/₂ x 4¹/₄, mounted on album page
11³/₄ x 14¹/₂

|461| 83.Stm.121
Mr. and Mrs. William Merritt
Chase on deck of the LUSITANIA,
c.1912
cyanotype
2¹/₂ x 4¹/₄, mounted on album page
11³/₄ x 14¹/₂

[462] 83.Stm.26
William Merritt Chase aboard the
LUSITANIA, c.1912
gelatin silver print
5⁵/₈ x 3¹/₄

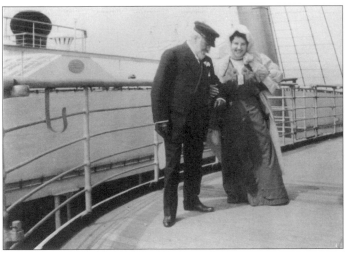

[461]

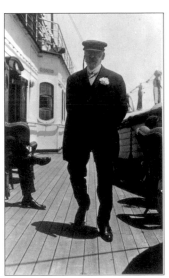

[462]

[463] 83.Stm.114
Deck of the LUSITANIA, c.1912
cyanotype
4 x 2¹/₂, mounted on album page
11³/₄ x 14¹/₂

[464] 83.Stm.119
Mrs. Chase and unidentified
woman on deck of the
LUSITANIA, c.1912
cyanotype
2³/₄ x 1¹/₂, mounted on album page
11³/₄ x 14¹/₂

[465] 83.Stm.130
Mrs. Chase and unidentified
woman on deck of the
LUSITANIA, c.1912
cyanotype
4¹/₄ x 3¹/₈, mounted on album page
11³/₄ x 14¹/₂

[466] 83.Stm.132
Mr. and Mrs. William Merritt
Chase and unidentified woman
(l. to r.) on deck of the LUSITANIA,
c.1912
cyanotype
3¹/₂ x 3¹/₂, mounted on album page
11³/₄ x 14¹/₂

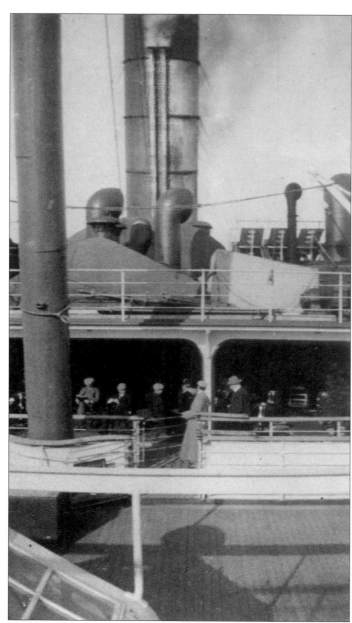

[463]

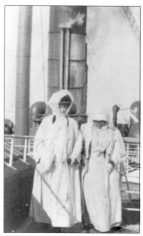

[464]

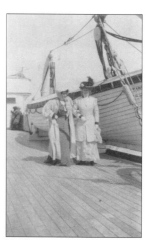

[465]

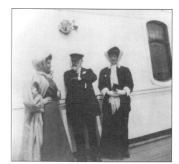

[466]

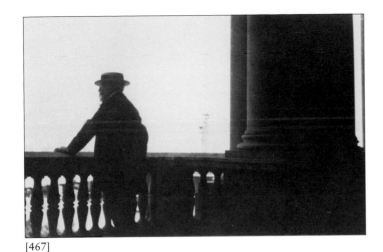

[467]

[468]

[469]

[470] 83.Stm.22
William Merritt Chase, c.1912
gelatin silver print
6⁷/₈ x 4⁵/₈

[471] 83.Stm.23
William Merritt Chase, c.1912
gelatin silver print
6¹/₂ x 4³/₄

[472] 89.Stm.41
William Merritt Chase, c.1912
gelatin silver print
6⁵/₈ x 4⁵/₈

[473] 83.Stm.19
Mr. and Mrs. William Merritt
Chase, c.1912
gelatin silver print
2³/₄ x 1³/₄

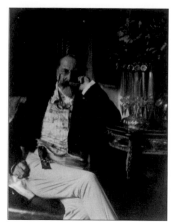

[470]

[471]

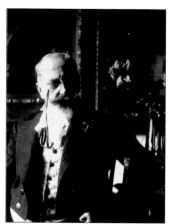

[472]

[473]

[474] 83.Stm.15
William Merritt Chase feeding
pigeons, Venice, c.1913
gelatin silver print
3$\frac{1}{2}$ x 4$\frac{1}{2}$

[474]

[475] 83.Stm.44
William Merritt Chase studio,
probably Shinnecock Hills;
SELF PORTRAIT (Rogers
Memorial Library, Southampton,
NY) on easel, c.1913.
gelatin printing-out paper
8¼ x 10

[476] 83.Stm.27
William Merritt Chase giving
painting demonstration at
Carmel-by-the-Sea, 1914
gelatin silver print
5⅝ x 3⁵/₁₆

[475]

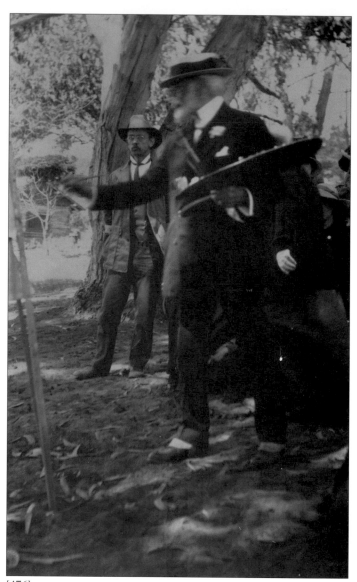

[476]

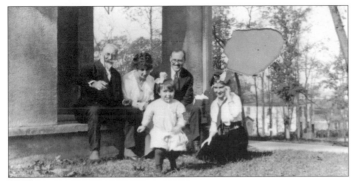

[477]

[478]

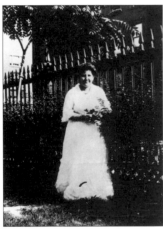

[479]

[480]

[481]

[477] 91.RGP.1
William Merritt Chase, Alice
Dieudonnée Sullivan, Arthur
Sullivan, Dorothy, Dorothy
Sullivan (Chase's granddaughter),
c.1914
gelatin printing-out paper
2¼ x 4⅛

[478] 83.Stm.70
Alice Dieudonnée Sullivan and her
daughter Dorothy, c.1916
cyanotype
2½ x 1⅝, mounted on album page
14 x 11¾

[479] 91.RGP.5
Mrs. Chase in her backyard,
234 East 15th Street, NYC
(inscribed verso: "Lady Valentine/
Mrs. William M. Chase"), c.1917
gelatin silver print
4½ x 2⅝

[480] 89.Stm.49
Studio interior, portrait oil sketch
of Mary Content in background,
SELF PORTRAIT (Art Association
of Richmond, Indiana) in
foreground, c.1916
gelatin silver print
7⅞ x 9⅜

[481] 91.RGP.2
Mrs. Chase (standing, left of
center) and her two grandchildren,
Dorothy Sullivan, and Arthur
Sullivan at unveiling of bust of
William M. Chase (by Albin
Polasek), The Hall of
Remembrance, New York
University, 1923
gelatin silver print
3⅛ x 5⅜

[482] 76.Mc.26d
Dr. Fisher standing behind wagon, with unidentified children, Mrs. Chase, unidentified woman, and Robert in wagon, probably Swiftwater, PA, 1911
cyanotype
2$\frac{1}{4}$ x 3$\frac{1}{4}$

[483] 76.Mc.26e
Robert, Roland, and Mary Content, probably Swiftwater, PA, 1911
cyanotype
2$\frac{1}{4}$ x 3$\frac{1}{4}$

[484] 76.Mc.26f
Dr. Fisher standing in front of carriage with unidentified figures inside, probably Swiftwater, PA, 1911
cyanotype
2$\frac{1}{4}$ x 3$\frac{1}{4}$

[485] 76.Mc.26g
Dr. Fisher at the reins, probably Swiftwater, PA, 1911
cyanotype
2$\frac{1}{4}$ x 3$\frac{1}{4}$

[486] 76.Mc.26h
Rapids, probably Swiftwater, PA, 1911
cyanotype
2$\frac{1}{4}$ x 3$\frac{1}{4}$

[487] 76.Mc.26i
Mountain scenery, probably Swiftwater, PA, 1911
cyanotype
2$\frac{1}{4}$ x 3$\frac{1}{4}$

[488] 76.Mc.27a
Robert and Roland in distance, Fisher boy, and Mary Content in front, probably Swiftwater, PA, 1911
cyanotype
3$\frac{1}{4}$ x 2$\frac{1}{4}$

[489] 76.Mc.27b
Mary Content with Fisher boy, probably Swiftwater, PA, 1911
cyanotype
3$\frac{1}{4}$ x 2$\frac{1}{4}$

[490] 76.Mc.27c
Fisher boy and Mary Content playing, probably Swiftwater, PA, 1911
cyanotype
3$\frac{1}{4}$ x 2$\frac{1}{4}$

[491] 76.Mc.27d
Mary Content, unidentified woman, and Fisher boy, probably Swiftwater, PA, 1911
cyanotype
2$\frac{1}{4}$ x 3$\frac{1}{4}$

[492] 76.Mc.27e
Unidentified group with Roland on the left and Robert on the right, probably Swiftwater, PA, 1911
cyanotype
2$\frac{1}{4}$ x 3$\frac{1}{4}$

[493] 76.Mc.27f
Unidentified woman with Fisher boy, Mary Content, Robert and Roland, probably Swiftwater, PA, 1911
cyanotype
2$\frac{1}{4}$ x 3$\frac{1}{4}$

[494] 76.Mc.27g
Children playing, Robert and Mary Content at right, probably Swiftwater, PA, 1911
cyanotype
2$\frac{1}{4}$ x 3$\frac{1}{4}$

[495] 76.Mc.27h
Mrs. Chase with Mary Content in background, probably Swiftwater, PA, 1911
cyanotype
2$\frac{1}{4}$ x 3$\frac{1}{4}$

[496] 76.Mc.27i
Unidentified figures, probably Swiftwater, PA, 1911
cyanotype
2$\frac{1}{4}$ x 2$\frac{1}{4}$

[497] 76.Mc.27j
Robert, probably Swiftwater, PA, 1911
cyanotype
2$\frac{1}{4}$ x 2$\frac{1}{4}$

[498] 83.Stm.106
Interior main room, Chase villa, c.1911
cyanotype
4$\frac{1}{4}$ x 2$\frac{1}{2}$, mounted on album page 14 x 11$\frac{3}{4}$

[499] 83.Stm.111
Chase villa, c.1911
cyanotype
4$\frac{1}{4}$ x 2$\frac{1}{2}$, mounted on album page 14 x 11$\frac{3}{4}$

[500] 83.Stm.100
Mr. and Mrs. William Merritt Chase in pony cart, c.1911
cyanotype
2$\frac{1}{2}$ x 4$\frac{1}{4}$, mounted on album page 14 x 11$\frac{3}{4}$

[501] 83.Stm.87
View of Florence, c.1911
cyanotype
2$\frac{1}{2}$ x 3$\frac{7}{8}$, mounted on album page 14 x 11$\frac{3}{4}$

[502] 83.Stm.88
Facade of a villa, Florence, c.1911
cyanotype
4$\frac{1}{4}$ x 2$\frac{1}{2}$, mounted on album page 14 x 11$\frac{3}{4}$

[503] 83.Stm.89
Ponte Vecchio, Florence, c.1911
cyanotype
2$\frac{3}{8}$ x 4$\frac{1}{4}$, mounted on album page 14 x 11$\frac{3}{4}$

[504] 83.Stm.91
View of Florence, c.1911
cyanotype
2$\frac{1}{2}$ x 4$\frac{1}{4}$, mounted on album page 14 x 11$\frac{3}{4}$

[505] 83.Stm.92
View of Florence, c.1911
cyanotype
2$\frac{1}{2}$ x 4$\frac{1}{4}$, mounted on album page 14 x 11$\frac{3}{4}$

[506] 83.Stm.94
Hills of Fiesole, c.1911
cyanotype
2$\frac{1}{2}$ x 4$\frac{1}{4}$, mounted on album page 14 x 11$\frac{3}{4}$

[507] 83.Stm.95
Unidentified man with William Merritt Chase, Florence, c.1911
cyanotype
2$\frac{1}{2}$ x 4$\frac{1}{2}$, mounted on album page 14 x 11$\frac{3}{4}$

[508] 83.Stm.96
Marketplace, Florence, c.1911
cyanotype
2$\frac{1}{2}$ x 4$\frac{1}{4}$, mounted on album page 14 x 11$\frac{3}{4}$

[509] 83.Stm.97
Street in Florence, c.1911
cyanotype
2$\frac{1}{2}$ x 4, mounted on album page 14 x 11$\frac{3}{4}$

[510] 83.Stm.99
Florence, c.1911
cyanotype
4$\frac{1}{4}$ x 2$\frac{1}{2}$, mounted on album page 14 x 11$\frac{3}{4}$

[511] 83.Stm.102
Looking up a road in Fiesole, c.1911
cyanotype
2$\frac{1}{2}$ x 4$\frac{1}{4}$, mounted on album page 14 x 11$\frac{3}{4}$

[512] 83.Stm.104
View from hills of Fiesole, c.1911
cyanotype
2¹/₂ x 4¹/₄, mounted on album page
14 x 11³/₄

[513] 83.Stm.108
View from Chase villa, c.1911
cyanotype
2¹/₂ x 4¹/₄, mounted on album page
14 x 11³/₄

[514] 83.Stm.109
Gates to Chase villa, c.1911
cyanotype
2¹/₂ x 4¹/₄, mounted on album page
14 x 11³/₄

[515] 83.Stm.110
Mrs. Chase and unidentified
person, c.1911
cyanotype
2 x 2¹/₂, mounted on album page
14 x 11³/₄

[516] 83.Stm.158
View from deck of LUSITANIA,
c.1912
gelatin printing-out paper
1¹/₂ x 2, mounted on album page
14¹/₄ x 15¹/₄

[517] 83.Stm.115
Deck of the LUSITANIA, c.1912
cyanotype
4¹/₈ x 2¹/₂, mounted on album page
11³/₄ x 14¹/₂

[518] 83.Stm.116
Mrs.Chase aboard the
LUSITANIA, c.1912
cyanotype
2 x 2³/₄, mounted on album page
11³/₄ x 14¹/₂

[519] 83.Stm.117
William Merritt Chase on deck of
the LUSITANIA, c.1912
cyanotype
4¹/₄ x 2¹/₂, mounted on album page
11³/₄ x 14¹/₂

[520] 83.Stm.118
Unidentified man on deck of the
LUSITANIA, c.1912
cyanotype
4¹/₄ x 2¹/₂, mounted on album page
11³/₄ x 14¹/₂

[521] 83.Stm.122
Fragment with two unidentified
people, c.1912
cyanotype
2⁵/₈ x 1¹/₄, mounted on album page
11³/₄ x 14¹/₂

[522] 83.Stm.123
Unidentified man and woman with
William Merritt Chase on deck of
the LUSITANIA, c.1912
cyanotype
2¹/₂ x 4¹/₄, mounted on album page
11³/₄ x 14¹/₂

[523] 83.Stm.124
Two unidentified couples on deck
of the LUSITANIA, c.1912
cyanotype
2¹/₂ x 4, mounted on album page
11³/₄ x 14¹/₂

[524] 83.Stm.125
Ships seen from deck of the
LUSITANIA, c.1912
cyanotype
4¹/₄ x 2¹/₄, mounted on album page
11³/₄ x 14¹/₂

[525] 83.Stm.126
Unidentified man on deck of the
LUSITANIA, c.1912
cyanotype
4¹/₄ x 2¹/₂, mounted on album page
11³/₄ x 14¹/₂

[526] 83.Stm.127
LUSITANIA coming into port,
c.1912
cyanotype
4 x 2, mounted on album page
11³/₄ x 14¹/₂

[527] 83.Stm.128
Unidentified couple with William
Merritt Chase and unidentified
woman (with backs to viewer) on
deck of the LUSITANIA, c.1912
cyanotype
4¹/₄ x 2¹/₂, mounted on album page
11³/₄ x 14¹/₂

[528] 83.Stm.129
Unidentified woman and man in
parlor flanking William Merritt
Chase (seated) and Mrs. Chase
(standing) inside of the
LUSITANIA, c.1912
gelatin printing-out paper
3¹/₂ x 3¹/₂, mounted on album page
11³/₄ x 14¹/₂

[529] 83.Stm.131
Unidentified man seated on deck
of the LUSITANIA, c.1912
cyanotype
3¹/₄ x 3¹/₈, mounted on album page
11³/₄ x 14¹/₂

[530] 83.Stm.133
Lifeboat of the LUSITANIA on
deck, c.1912
cyanotype
3¹/₄ x 3³/₈, mounted on album page
11³/₄ x 14¹/₂

[531] 83.Stm.134
Unidentified woman on deck of
the LUSITANIA, c.1912
cyanotype
1³/₄ x 1¹/₄, mounted on album page
11³/₄ x 14¹/₂

[532] 83.Stm.136
Unidentified woman on deck of
the LUSITANIA, c.1912
cyanotype
1³/₄ x 12¹/₂, mounted on album
page 11³/₄ x 14¹/₂

[533] 83.Stm.137
Unidentified couple on deck of the
LUSITANIA, c.1912
cyanotype
4¹/₄ x 2¹/₄, mounted on album page
11³/₄ x 14¹/₂

[534] 83.Stm.138
Unidentified woman on deck of
the LUSITANIA, c.1912
cyanotype
4¹/₄ x 1⁵/₈, mounted on album page
11³/₄ x 14¹/₂

[535] 83.Stm.139
Unidentified man standing on deck
of the LUSITANIA, c.1912
cyanotype
4¹/₄ x 2¹/₈, mounted on album page
11³/₄ x 14¹/₂

[536] 83.Stm.140
Unidentified man seated on deck
of the LUSITANIA, c.1912
cyanotype
4¹/₄ x 2¹/₂, mounted on album page
11³/₄ x 14¹/₂

[537] 89.Stm.40
William Merritt Chase [slightly
larger version of 89.Stm.28],
c.1912
gelatin silver print
6³/₈ x 4¹/₂

[538] 89.Stm.28
William Merritt Chase
[duplicate 89.Stm.40], c.1912
gelatin silver print
5⁵/₈ x 4⁵/₈

[539] 89.Stm.46
William Merritt Chase, c.1912
gelatin silver print
6¹/₂ x 4⁵/₈

[540] 89.Stm.81
William Merritt Chase seated,
c.1912
gelatin silver print
9¹/₂ x 6³/₄

[541] 89.Stm.8
Mr. and Mrs. William Merritt
Chase [duplicate 89.Stm.9;
83.Stm.29], c.1911
gelatin silver print
1¾ x 2½

[542] 89.Stm.9
Mr. and Mrs. William Merritt
Chase [duplicate 89.Stm.8;
83.Stm.29], c.1911
gelatin silver print
1¼ x 1¼

[543] 89.Stm.68
Mrs. Chase and infant, possibly a
grandchild, c.1917
gelatin silver print
5 x 3⅛

[544] 89.Stm.38
Unidentified woman, date unknown
gelatin silver print
6½ x 4½

[545] 76.Mc.60
Unidentified young girl,
date unknown
gelatin silver print
5¾ x 3⅝, mounted on black board
10 x 8

[546] 89.Stm.25
Unidentified girl, Shinnecock Hills,
c.1905
cyanotype
4⅛ x 2½

[547] 89.Stm.23
Old building and orchard,
probably European, date unknown
gelatin silver print
4⅜ x 3¼

[548] 89.Stm.60
Unidentified rocky coast line
gelatin silver print
2½ x 4¾

[549] 89.Stm.64
View of unidentified house
gelatin silver print
3½ x 3½

[550] 83.Stm.143
Religious procession (inscribed
lower border: "no. 3154-Sevilla-
Semana Santa-nuestra Senora del
Partracinio[?]"), date unknown
gelatin printing-out paper
5¼ x 4, mounted on cardboard
13¾ x 15

[551] 89.Stm.76
Unidentified man seated in front of
a wall of paintings (not by Chase),
(inscribed front, lower right:
"W.L. Bruckman"), date unknown
gelatin silver print
4¼ x 3¼

[552] 83.Stm.77
Unidentified woman, date unknown
cyanotype
2⅞ x 1⅛, mounted on album page
14 x 11¾

[553] 85.Mcr.14
Unidentified woman, date unknown
gelatin printing-out paper
3¼ x 2¼

[554] 89.Stm.82
Interior, portrait of unidentified
man by Chase on easel
gelatin silver print
7¾ x 9⅝

[555] 89.Stm.27
Unidentified studio (inscribed
verso: "Sincerely yours/Albert
Garcia Marshall."), date unknown
gelatin silver print
4 x 5, mounted on board 5½ x 7

[556] 89.Stm.47
Unidentified studio with
reproduction of PORTRAIT OF
MRS. C. (LADY WITH A WHITE
SHAWL) (Pennsylvania Academy
of the Fine Arts, Philadelphia),
date unknown
gelatin silver print
5 x 7

[557] 89.Stm.66
Mrs. Chase leaning out of
window of unidentified house,
date unknown
gelatin silver print
4¼ x 2½

[558] 77.Mc.18
Unidentified child, date unknown
gelatin printing-out paper
1⁷⁄₁₆ x 2

[559] 83.Stm.156
Unidentified woman in front of
mirror, date unknown
gelatin printing-out paper
3¼ x 3½, mounted on album page
14¼ x 15¼

[560]

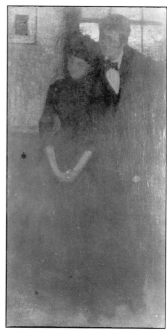

[561]

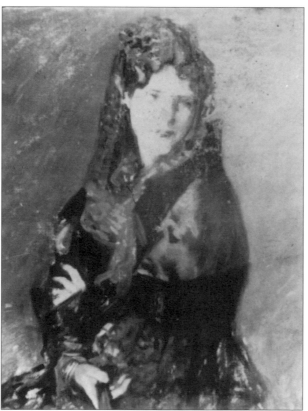

[563]

[562]

[564]

[560] 83.Stm.52
Painting by William Merritt
Chase, FEEDING THE BABY,
c.1887
gelatin silver print
6 x 4¹/₈, mounted on board 10 x 8

[561] 89.Stm.90
Photograph of a painting, two
figures standing and facing
forward, man in back looking over
woman's shoulder (inscribed
lower left: "To my friend[?]
Wm. M. Chase/Whistler/1887 &
1888?"; inscribed verso: "This
picture hung in my husband's/
studio. But I never heard him/
call it a Whistler, nor anyone/
else. However it is a good painting/
who ever painted it./Mrs. Wm. M.
Chase/Nov. 14th 1925"), c.1887
gelatin silver print
9 x 4⁵/₈

[562] 83.Stm.157
Portrait of Mrs. Chase, c.1895
gelatin printing-out paper
2³/₄ x 2¹/₈, mounted on album page
14¹/₄ x 15¹/₄

[563] 77.Mc.69
William Merritt Chase's painting
THE BAYBERRY BUSH, c.1895
(The Parrish Art Museum,
Southampton, NY)
gelatin printing-out paper
1¹/₄ x 1³/₄

[564] 91.RGP/PS.1
MRS. CHASE AS A SPANISH
LADY (sold Christie's,
Nov.30, 1990), c.1896,
gelatin printing-out paper
2 x 1¹/₂

[565] 77.Mc.10
Portrait of Alice Dieudonnée,
YOUNG GIRL IN BLACK
(Artist's Daughter Alice in
Mother's Dress), (Hirshhorn
Museum and Sculpture Garden,
Washington, D.C.), c.1899
gelatin printing-out paper
1³/₄ x 1

[566] 77.Mc.11
Portrait of Alice Dieudonnée
(formerly Newhouse Galleries,
NYC), c.1898
gelatin printing-out paper
1³/₁₆ x 1

[567] 77.Mc.12
Portrait of Alice Dieudonnée
(formerly Ira Spanierman Gallery,
NYC), c.1898
gelatin printing-out paper
1¹/₄ x 1¹/₈

[568] 77.Mc.13
Portrait of one of the artist's
daughters, DEVOTION, (Private
Collection, NYC), c.1898
gelatin printing-out paper
1⁵/₁₆ x ³/₄

[569] 77.Mc.45
Portrait of Helen, now titled
LITTLE RED RIDING HOOD,
(Delaware Art Museum), c.1900
gelatin printing-out paper
2⁷/₈ x 2¹/₂

[570] 77.Mc.52
THE MIRROR (Cincinnati Art
Museum), c.1900
gelatin printing-out paper
2⁷/₈ x 2¹/₄

[565]

[566]

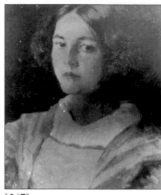

[567]

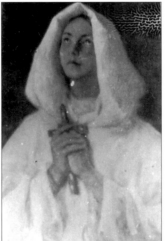

[568]

[569]

[570]

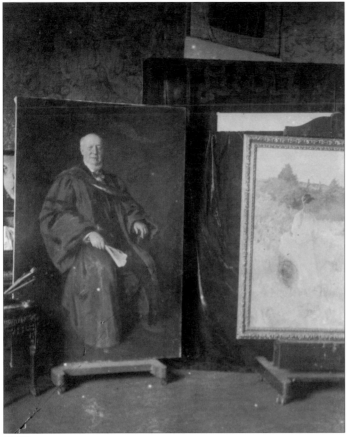

[571]

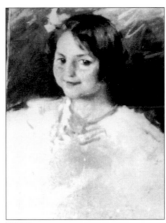

[572]

[573]

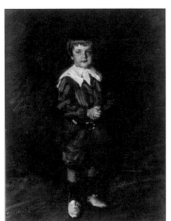

[574]

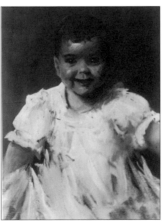

[575]

[571] 89.Stm.30
Interior with Chase portrait of a
distinguished gentleman on easel
(formal portrait commission)
and Chase's painting
AN AFTERNOON STROLL
(San Diego Museum of Art),
c.1900
gelatin silver print
6¼ x 4½

[572] 77.Mc.9
Portrait of Helen, c.1901
gelatin printing-out paper
1½ x 2

[573] 91.RGP/PS.31
DOROTHY CHASE (Indianapolis
Museum of Art), (inscribed verso:
Dorothy), c.1902
gelatin printing-out paper
6½ x 3¾

[574] 91.RGP/PS.35
ROBERT CHASE (The High
Museum, Atlanta, GA), (inscribed
verso: "Robert"), c.1902
gelatin printing-out paper
6 x 4½ (see 77.Mc.8)

[575] 91.RGP/PS.33
ROLAND DANA CHASE
(Metropolitan Museum of Art,
NYC), (inscribed verso:
"Roland Chase"), c.1902
gelatin printing-out paper
6 x 4⅝

[576] 77.Mc.44
Portrait of Alice Dieudonnée,
THE GRAY KIMONO (formerly
Hirschl & Adler Galleries, NYC),
c.1902
gelatin printing-out paper
2⁵/₁₆ x 1⁷/₈

[577] 91.RGP/PS.34
MY DAUGHTER DIEUDONNÉE
(The Parrish Art Museum,
Southampton, NY), (inscribed
verso: "Alice Dieudonnée Chase"),
c.1902
gelatin printing-out paper
6¹/₂ x 3³/₄

[578] 91.RGP/PS.2
MISS WILLARD (inscribed
verso: "Painted before class,
Miss Willard— student"), c.1902
gelatin printing-out paper
1¹/₂ x 2

[579] 91.RGP/PS.3
PORTRAIT OF ROBERT
STEWART CHASE (probably a
demonstration piece), c.1902
gelatin printing-out paper
1¹/₂ x 2

[580] 91.RGP/PS.5
SEASIDE FLOWERS, c.1897
(Private Collection), c.1902
gelatin printing-out paper
1¹/₂ x 2

[576]

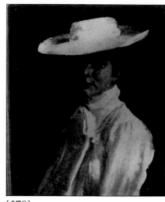
[578]

[577]

[579]

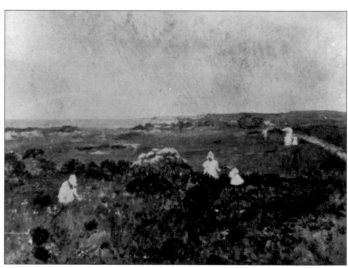
[580]

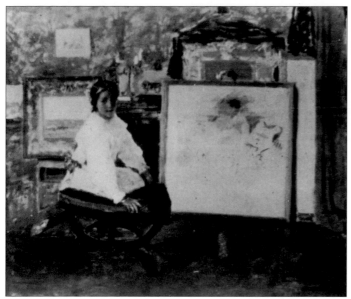

[581]

[583]

[582]

[581] 91.RGP/PS.8
DID YOU SPEAK TO ME?, 1900
(The Butler Institute of American
Art, Youngstown, OH), (inscribed
verso: "Painting by Mr. Chase
'Did you Speak to me?'/ Taken by
Frank [Wadsworth] with our little
camera."), c.1902
gelatin printing-out paper
1¹/₂ x 2

[582] 91.RGP/PS.11
THE BAYBERRY BUSH, c.1895,
(The Parrish Art Museum,
Southampton, NY), c.1902
gelatin printing-out paper
1¹/₂ x 2

[583] 91.RGP/PS.12
IN THE STUDIO, c.1892
(Mr. and Mrs. Arthur Altschul)
c.1902
gelatin printing-out paper
1¹/₂ x 2

113

[584] 91.RGP/PS.13
MODEL (demonstration piece),
(inscribed verso: "Model—
Mr. Chase/ before class")
gelatin printing-out paper, 1902
1¹/₂ x 2

[585] 91.RGP/PS.16
STILL LIFE (demonstration piece),
(inscribed verso: "Still Life/ Mr.
Chase"), 1902
gelatin printing-out paper
1¹/₂ x 2

[586] 91.RGP/PS.15
STILL LIFE (demonstration piece),
(sold Sotheby's, N.Y.,
Nov. 30, 1989), (inscribed verso:
" 'Still Life,' painted before class—
W.M.C., 1902"), 1902
gelatin printing-out paper
1¹/₂ x 2

[587] 91.RGP/PS.17
KATE FREEMAN CLARK
(demonstration piece),
(Kate Freeman Clark Art Gallery,
Holly Springs, MS), (inscribed
verso: "Model/Mr. Chase/
before class,"), 1902
gelatin printing-out paper
1¹/₂ x 2

[588] 91.RGP/PS.18
GIRL WITH FAN (Montgomery
Museum of Fine Arts,
Montgomery, AL), (inscribed
verso: "Model/Mr. Chase/
before class"), c.1902
gelatin printing-out paper
1¹/₂ x 2

[584]

[585]

[586]

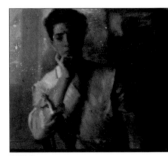
[587]

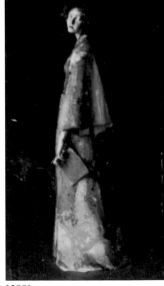
[588]

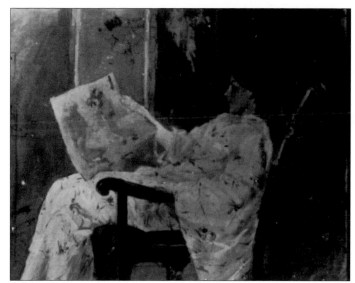

[589]

[591]

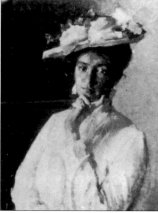

[590]

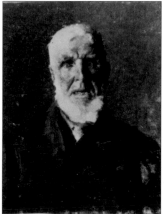

[592]

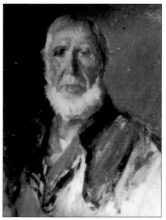

[593]

[589] 91.RGP/PS.19
THE JAPANESE PRINT, c.1888
(Neue Pinakothek, Munich,
Germany), (inscribed verso:
"picture by M. Chase"), c.1902
gelatin printing-out paper
1$\frac{1}{2}$ x 2$\frac{1}{4}$

[590] 91.RGP/PS.20
LADY IN WHITE (demonstration
piece, Indianapolis Art Museum),
(inscribed verso: "Painted before
class, 1902—model"), 1902
gelatin printing-out paper
1$\frac{1}{2}$ x 2

[591] 91.RGP/PS.21
SHINNECOCK HILLS
(demonstration piece), (inscribed
verso: "Landscape/Mr. Chase/
before class"), 1902
gelatin printing-out paper
1$\frac{1}{2}$ x 2

[592] 91.RGP/PS.22
Old Mr. Woodburn
(demonstration piece), (inscribed
verso: "Old Mr. Woodburn
painted before class by
W.M.Chase/ 1902"), 1902
gelatin printing-out paper
1$\frac{1}{2}$ x 2

[593] 91.RGP/PS.23
OLD MR. WOODBURN, 1902
(demonstration piece), (inscribed
verso: "Old Mr. Woodburn/
Mr. Chase/before class"), 1902
gelatin printing-out paper
1$\frac{1}{2}$ x 2

[594] 91.RGP/PS.24
STILL LIFE (demonstration piece),
(inscribed verso: "Still Life/
Mr. Chase"), 1902
gelatin printing-out paper
1½ x 2

[595] 91.RGP/PS.25
STILL LIFE (demonstration piece),
(inscribed verso: "Still Life/
Mr. Chase/ before class"), 1902
gelatin printing-out paper
1½ x 2

[594]

[595]

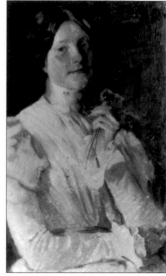

[596]

[596] 91.RGP/PS.26
LADY WITH RED FLOWER
(demonstration piece), (The Cornell
Fine Arts Center, Rollins College,
Winter Park, FL), (inscribed verso:
"Miss Covert/model—Mr. Chase/
before class"), 1902
gelatin printing-out paper
1½ x 2

[597] 91.RGP/PS.27
A LADY IN RED (demonstration
piece), (Private Collection),
(inscribed verso: "Painted by
Mr. Chase before class this
summer/ Miss Hall is[?] a student,
1902"), 1902
gelatin printing-out paper
1½ x 2

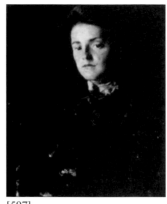

[597]

[598]

[598] 91.RGP/PS.28
MISS BOSLER (demonstration
piece), (inscribed verso:
"Miss Bosler/pupil — Mr. Chase/
before class"), 1902
gelatin printing-out paper
1½ x 2

[599] 77.Mc.8
PORTRAIT OF ROLAND,
c.1904
gelatin printing-out paper
1½ x 2

[599]

[600]

[601]

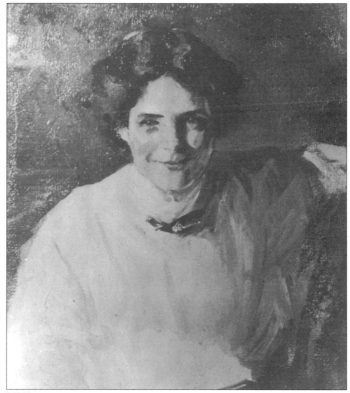

[602]

[603]

[600] 91.RGP/PS.30
PORTRAIT OF ROBERT
STEWART CHASE (inscribed
verso: "Portrait/Mr. Chase"),
c.1904
gelatin printing-out paper
1½ x 2

[601] 89.Stm.48
Painting, old master copy of
¾ length figure, date unknown
gelatin silver print
8¾ x 5¼

[602] 89.Stm.43
Demonstration portrait of a
woman, bust length, signed middle
left, "Chase.", date unknown
gelatin printing-out paper
6⅝ x 6⅛

[603] 89.Stm.86
Photograph of unidentified
painting/child seated at a table,
date unknown
gelatin silver print
9 x 6¾

Objects other than photographs

Decorative and utilitarian
objects once owned by
William Merritt Chase

78.cg.1–5

Original artwork by
William Merritt Chase
Includes etchings and drawings

78.11.cg6
82.11.32–64

Original artwork by artists other
than William Merritt Chase
Artists include:
Frederick S. Church
Zella de Milhau
Frederick Dielman
Delancey Gui
Emily Nichols Hatch
Friedrich Juengling
Ethel Paxson
J.H.E. Whitney
Henry Wolf

82.11.1–31
77.10.1cr
77.10.2cs

Letters from William Merritt
Chase, 1887–1914
Letters to:
Alice H. Barker
Dr. William and Mrs. Elizabeth
 Fisher
Mrs. Elizabeth Fisher
Mr. [Greer?]
Mrs. McGuire
F.B. McGuire
Mrs. [Minnigerode?]

77.Mc.70
77.Mc74
77.Mc89
77.Mc96–97

Letters to William Merritt Chase,
1883, 1901
Letters from: Students at
Shinnecock Summer School of Art
Joaquin Miller

77.Mc.77
83.Stm.1

Letters, postcards, and notes to
and from people other than
William Merritt Chase
Names of people:
Alice Chase
"Bobbie" [Robert Stewart] Chase
Helen Chase
Roland Dana Chase
Cosy [Alice Dieudonnée Chase]
Bessie Fisher
Dr. Fisher
Mrs. Fisher
Mrs. Wm. R. Fisher
Thomas Hubbard
Joaquin Miller
[Minnigerode?]
Newhouse Gallery
Toady [Mrs. William Merritt
 Chase]

76.Hu.1
76.Mc.3b–d
77.Mc.71–73, 77.Mc.75–76
77.Mc87–88
77.Mc.90–93
89.Stm.114

Original artwork by William
Merritt Chase

78.11cg6
82.11.32–64

Catalogues, brochures, books, and
other related printed material

78.Rs1–4
80.Bah.1
80.Gh.1
83.Stm.2a–3
89.Stm.101
89.Stm.112–113
89.Stm.115

Copies of photographs, newspaper
clippings, xerox copies, and
reproductions of artwork

PAM.1
76.Mc.1–3a
77.Mc.94
78.Brl.1
78.Brl.4–11
78.Brl.13
82.11.28
89.Stm.100
89.Stm.102–111

Copies of letters

77.Mc.78–86
77.Mc.95
78.Brl.12

Photographs of paintings by artists
other than William Merritt Chase

89.Stm.83–85
89.Stm.94–96
89.Stm.98